RUTH BERNHARD

THE ETERNAL BODY

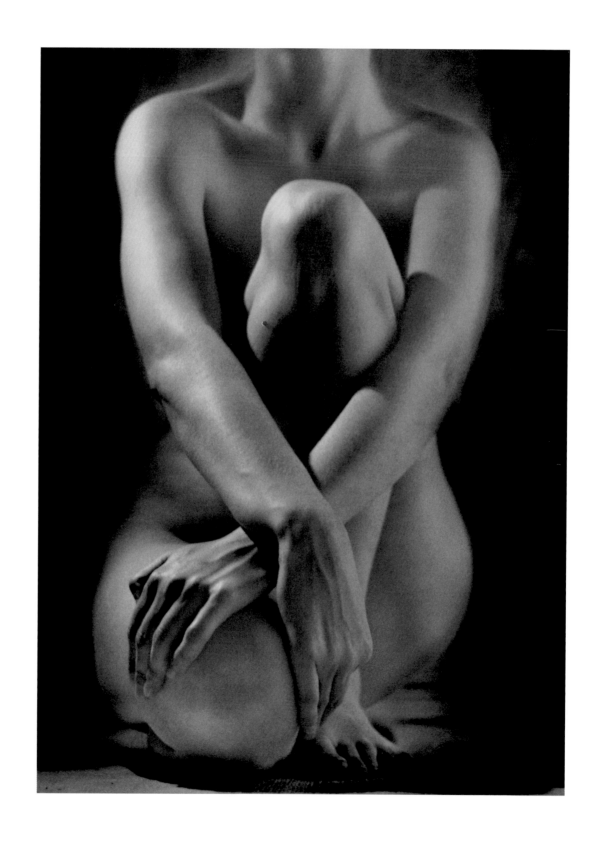

RUTH BERNHARD

THE ETERNAL BODY

a collection of fifty nudes

CHRONICLE BOOKS

SAN FRANCISCO

Library of Congress Cataloging-in-Publication data available.

ISBN: 978-0-8118-7759-6

Manufactured in China.

Book and cover design by Emily Dubin

10 9 8 7 6 5 4 3 2 1

Chronicle Books LLC
680 Second Street
San Francisco, CA 94107
www.chroniclebooks.com

FOREWORD

RUTH BERNHARD COLLECTED, studied, observed, examined, cherished, and photographed all manner of objects from Life Savers to dolls, but her study and love of the female nude was a lifelong pursuit: "The image of woman has been my mission." Bernhard's approach differed markedly from those of her male counterparts, whose images she felt either portrayed women as idealized models, Mother Earth figures, or erotic objects of desire. Diminutive in stature and solitary in her upbringing, Ruth Bernhard studied and understood women. She identified with and found beauty in each one, which she intensified through light. "Men photograph a female nude as if she belonged to them. I photograph a woman as part of the universe. The female body is the bearer of new life." Among the more than twenty artists whose work was included in Peter Lacey's *The History of the Nude in Photography*, published in 1964, it is telling that Ruth Bernhard was the only woman photographer.

During the 1950s and 1960s, Bernhard produced most of the nude images for which she is known. In *The Eternal Body*, which first appeared in 1986 and is re-created here, twenty-nine of the fifty nude images were made in these two decades. This period paralleled her teaching career, and teaching the nude proved both challenging and rewarding. Her critiques could be harsh, but her philosophy was simply that "Students of photography have to learn not how to light, but how to love." If Bernhard didn't love her subject, she couldn't—and didn't—photograph it, but for her, love meant to identify completely with the object to be photographed; it did not equate to desire. "I could not photograph a person for whom I had desire, because personal feeling gets in the way of expression."

Her relationship with Edward Weston personified her meaning of love. "I have had many loves in my life, but I have never had a person in my life whom I loved more than Weston." Theirs was "the love of twin souls, not of a couple." Ruth Bernhard and Edward Weston shared an intensity of feeling and an all-consuming passion for their art, and they could be openly critical yet supportive of each other's work. Bernhard stated with brutal honesty that Edward Weston's images of the female body were sensual and some of his nudes beautiful, "but when I think of them I see his interest in seduction and connection. . . . I see the man in the picture every time." In contrast, Bernhard's goal was abstraction and connection: to sculpt the body with light to achieve a universal idea of the body as art.

Like the remarkable 101-year life of this small but mighty woman, Ruth Bernhard's nudes are an expression of her passionate identification with and love for everything in the natural world.

—*Karen Sinsheimer*

RUTH BERNHARD

MY ENJOYMENT OF LIFE BEGAN with my eyes. Even as a small child, curiosity possessed me. The visible and invisible were my world, my fairy tale. In my eightieth year, the magic continues to linger. The world is always fresh. Looking at everything as if for the first time reveals the commonplace to be utterly incredible.

The ground we walk on, the plants and creatures, the clouds above constantly dissolving into new formations—each gift of nature possesses its own radiant energy, bound together by cosmic harmony.

Each animate and inanimate part of the whole exists in a tight network, interdependent and timeless. It is within this concept that my photographs suggest themselves to me. A minute insect, a mountain range, a human body—all share equal significance.

The diversity of my life's work is an attempt to express my sense of wonder at the amazing and miraculous world in which I find myself, and the mysteries which lie beyond. I am often reminded of the deceptive simplicity of the Japanese haiku, which, by the slightest nuance, evokes high moments and secret possibilities. Much of my work shares a similar intention.

The human body represents the same universal innocence, timelessness, and purity of all seedpods, suggesting the mother as well as the child, the parental as well as the descendant, conceived according to nature's longing. I strongly identify with this sense of continuity and in my work strive to exalt it.

In photographing the nude, it is my aim to transform the complexities of the figure into harmonies of simplified form, illuminating the innate life force and spirit as well as the underlying bone structure. The endless variety of nature's design and shapes amazes and thrills me.

I have approached my work with the nude much as I create a still life—with patience and reverence. My quest, through the magic of light and shadow, is to isolate, to simplify, and to give emphasis to form with the greatest clarity. To indicate ideal proportion, to reveal sculptural mass and the dominating spirit, is my goal.

Light is my inspiration, my paint and brush. It is as vital as the model herself. Profoundly significant, it caresses the essential superlative curves and lines. Light I acknowledge as the energy upon which all life on this planet depends.

For me, the creation of a photograph is experienced as a heightened emotional response, most akin to poetry and music, each image the culmination of a compelling impulse I cannot deny. Whether working with a human figure or a still life, I am deeply aware of my spiritual connection with it.

In my life, as in my work, I am motivated by a great yearning for balance and harmony beyond the realm of human experience, reaching for the essence of oneness with the Universe.

—*Ruth Bernhard, 1986*

THE ETERNAL BODY

PLATE 1

IN THE CIRCLE

1934

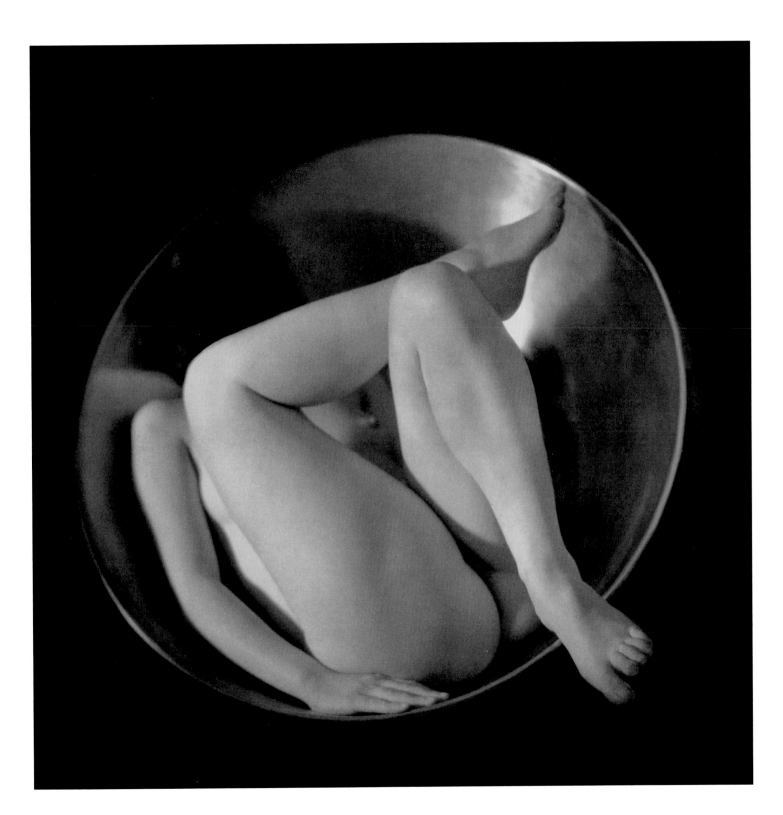

PLATE 2

EMBRYO

1934

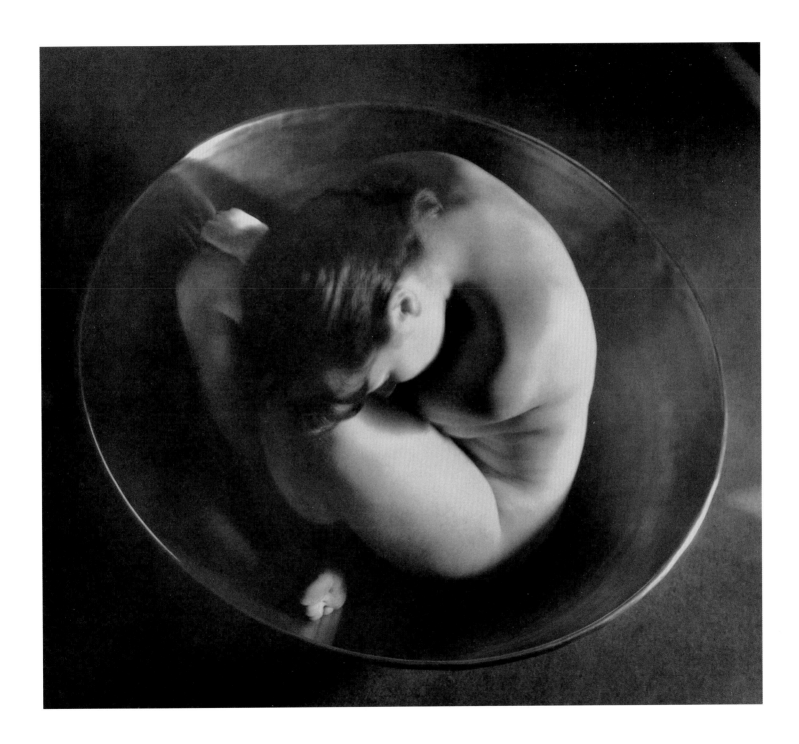

PLATE 3

EARLY NUDE

1934

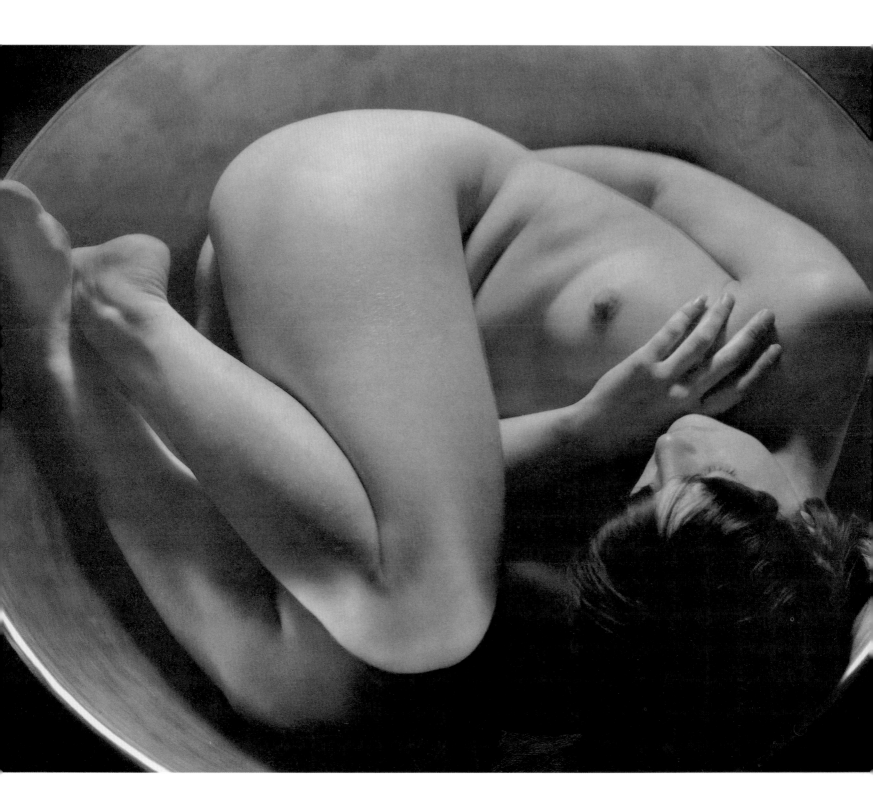

PLATE 4

WET SILK

1938

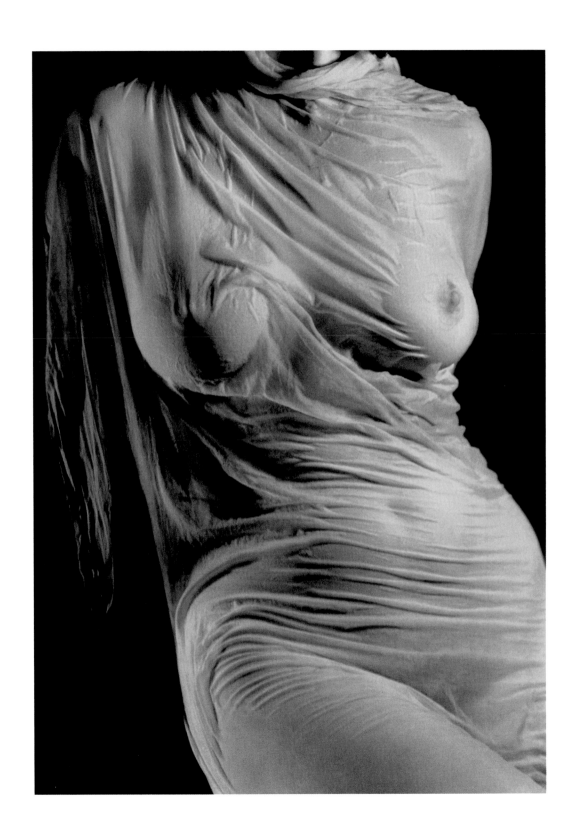

PLATE 5

IN THE WAVE

1945

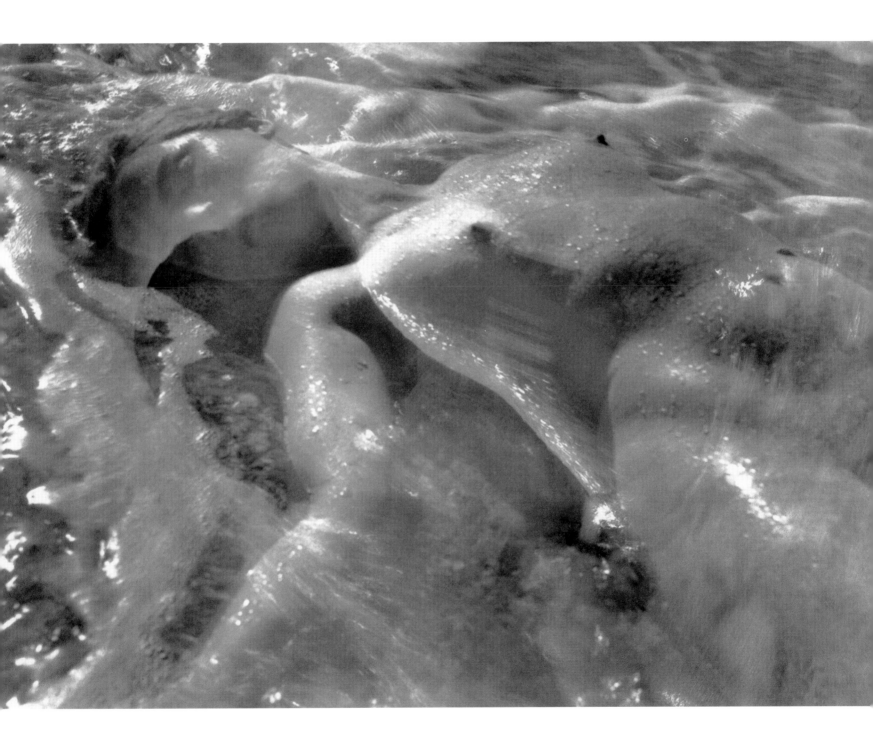

PLATE 6

TRIANGLES

1946

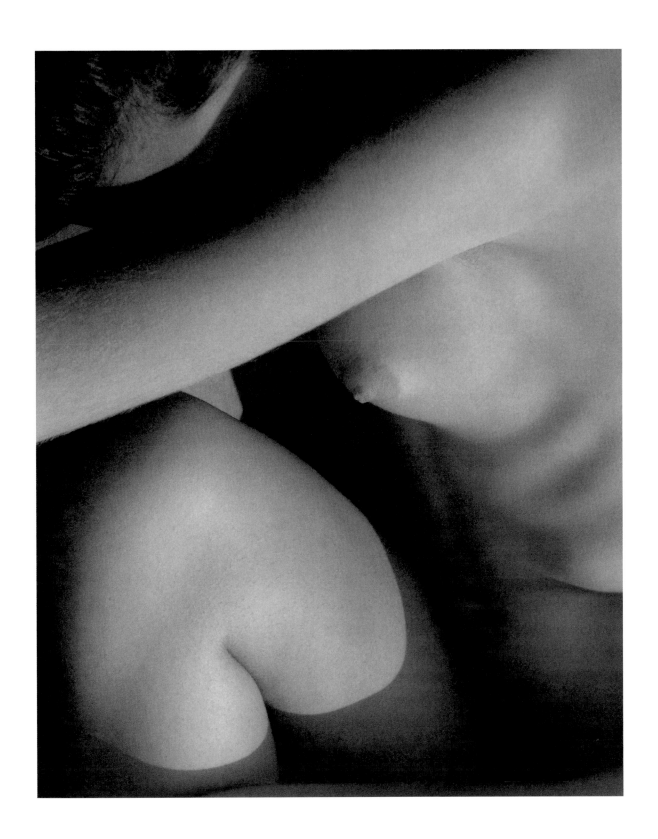

PLATE 7

ABSTRACT TORSO

1947

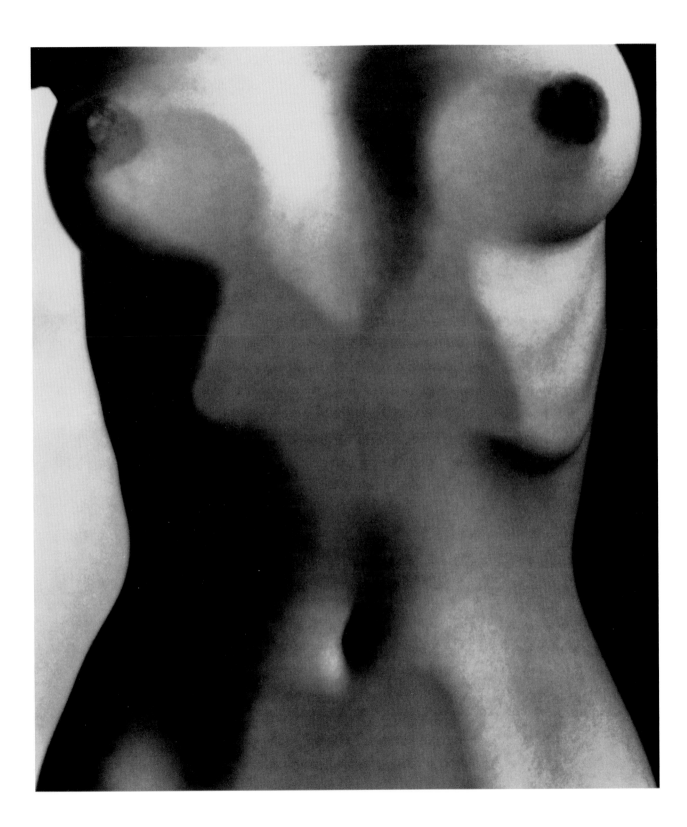

PLATE 8

AT THE POOL

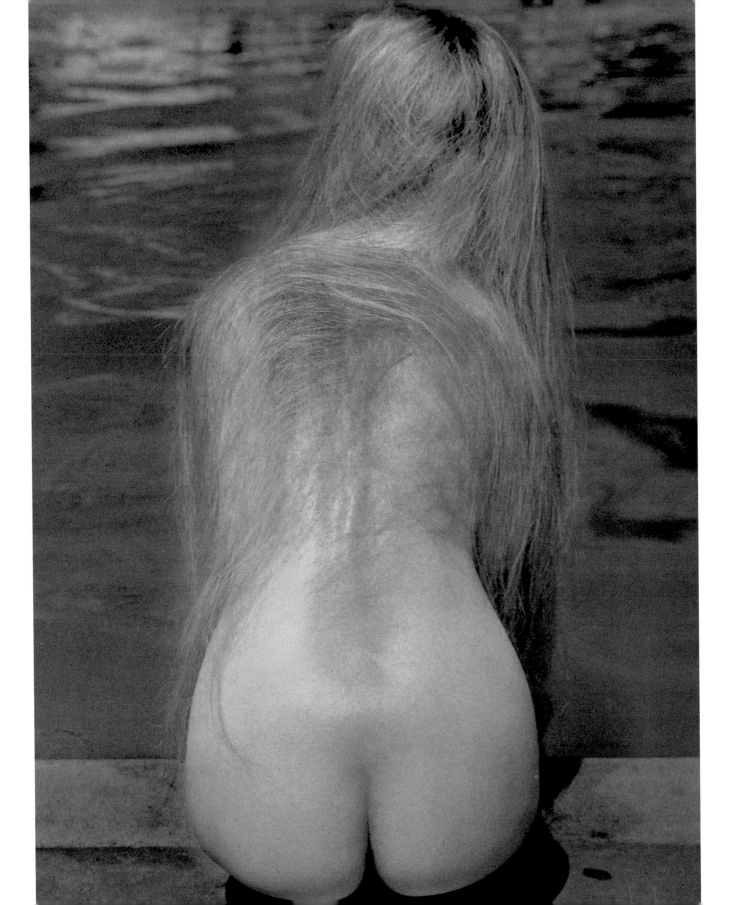

PLATE 9

AGAINST THE LIGHT

1951

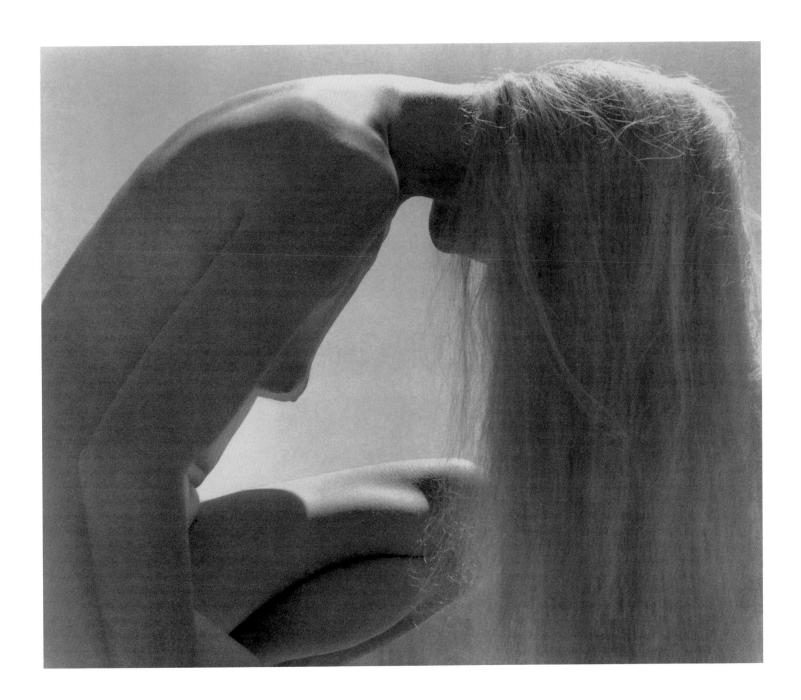

PLATE 10

DANCER'S HIPS

1951

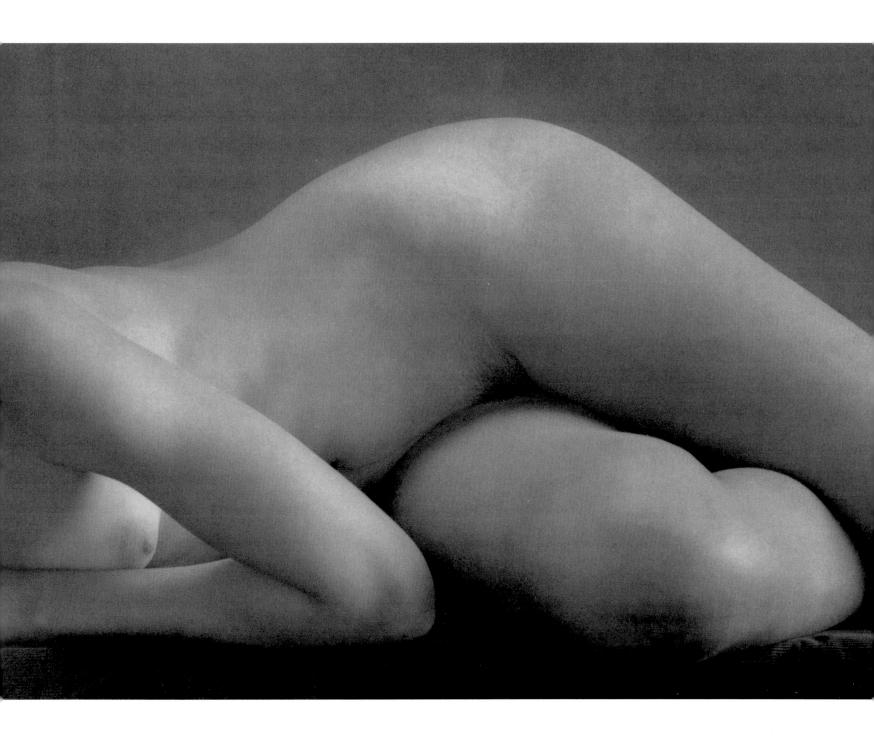

PLATE 11

DANCER IN REPOSE

1951

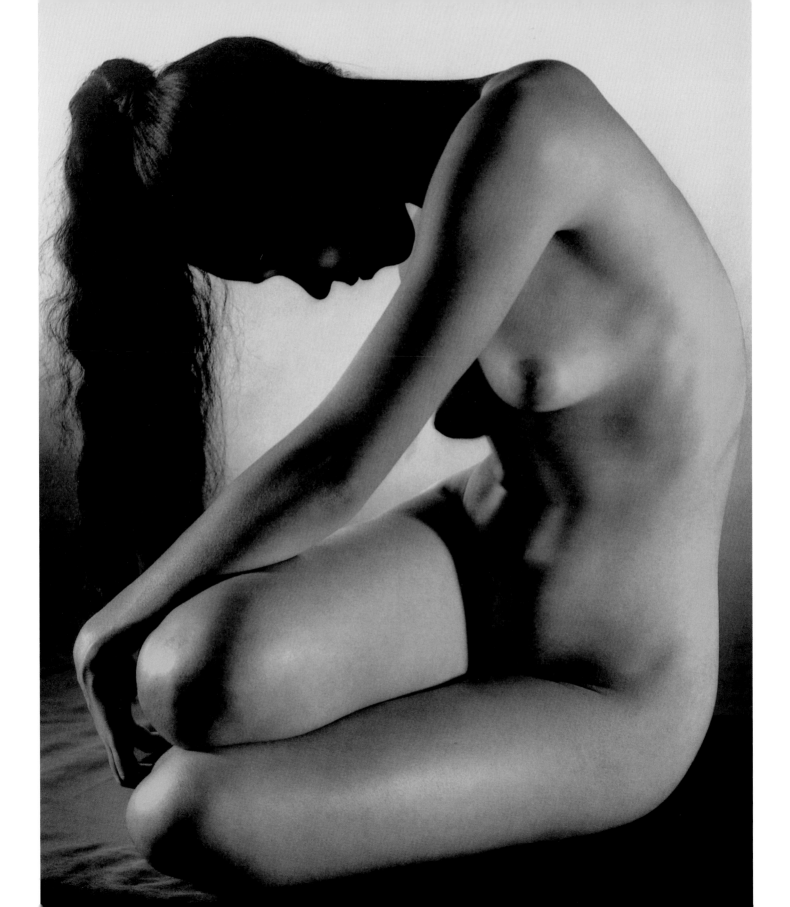

PLATE 12

CLASSIC TORSO

1952

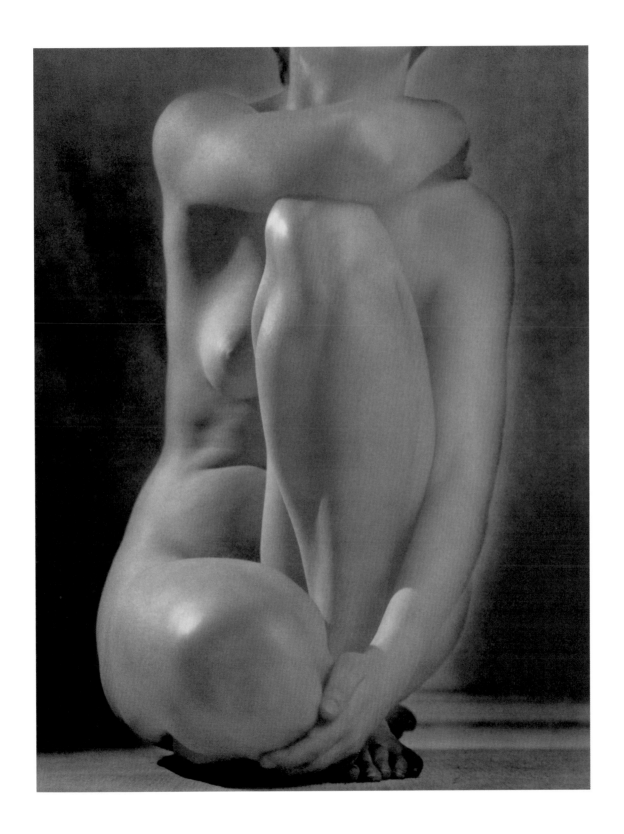

PLATE 13

HARVEST

1953

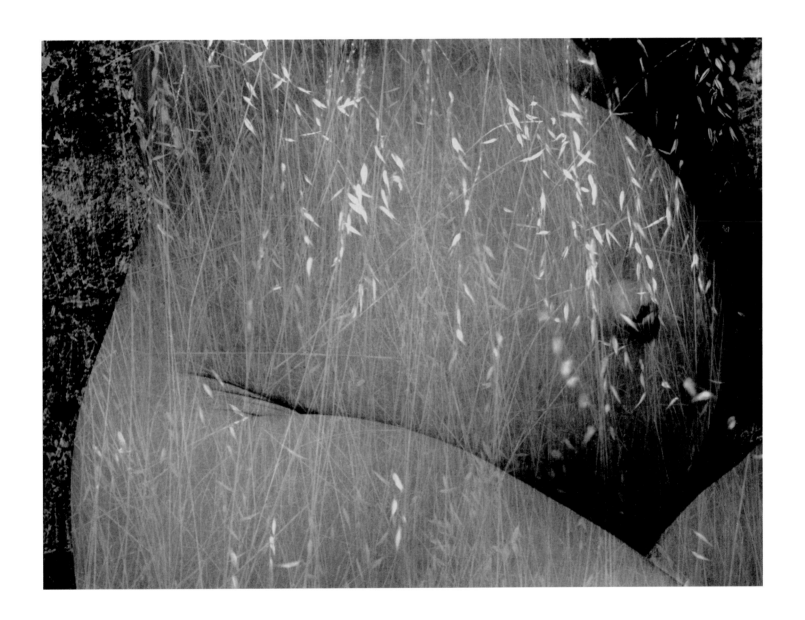

PLATE 14

NECK STUDY

1958

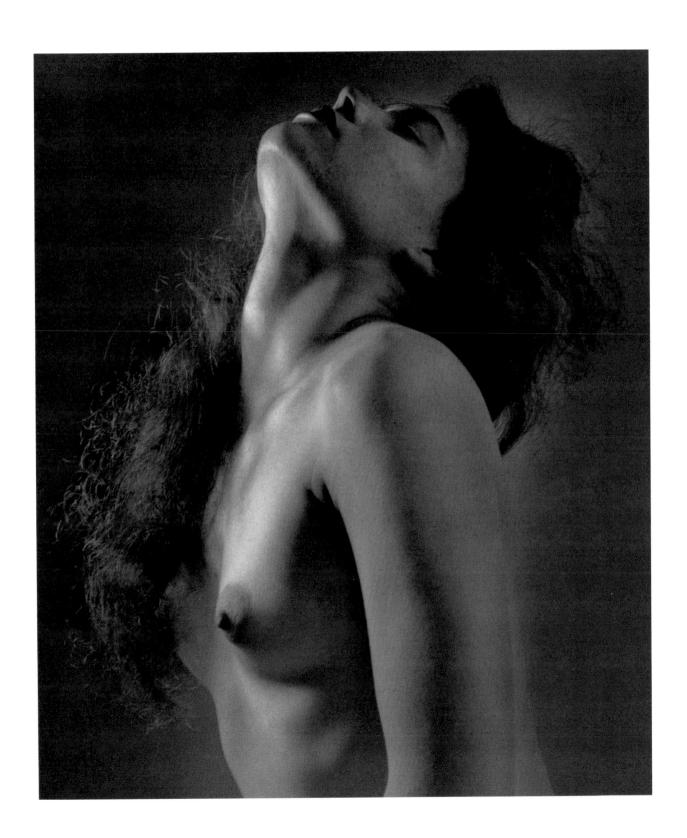

PLATE 15

AFRICAN

1959

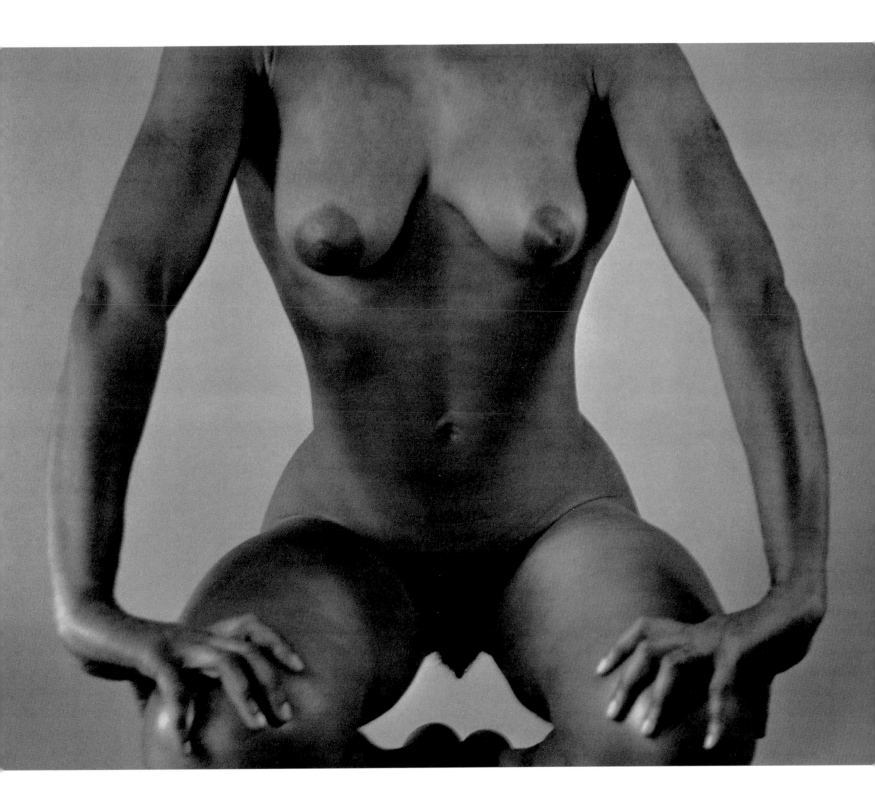

PLATE 16

AT THE MIRROR

1959

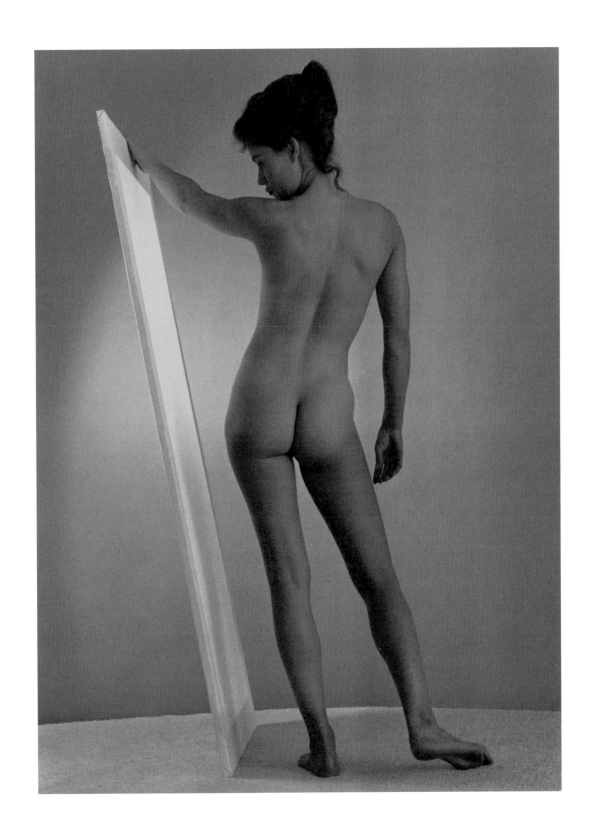

PLATE 17

DRAPED TORSO

1962

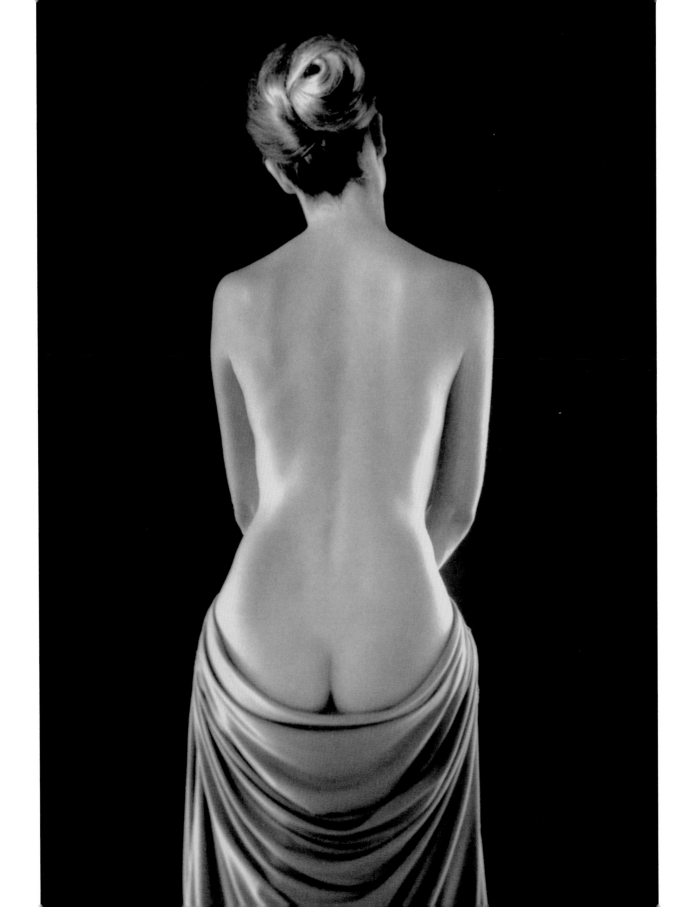

PLATE 18

OVAL NUDE

1962

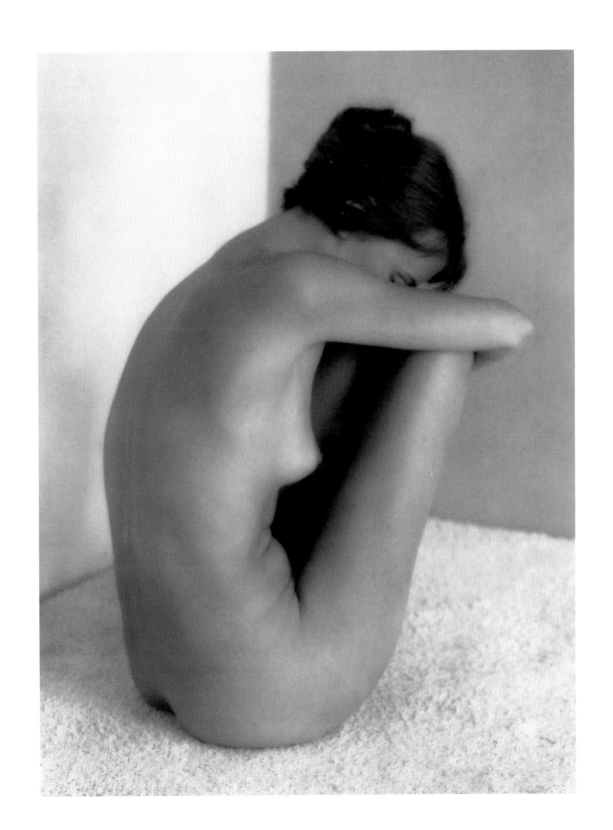

PLATE 19

IN THE BOX, HORIZONTAL

1962

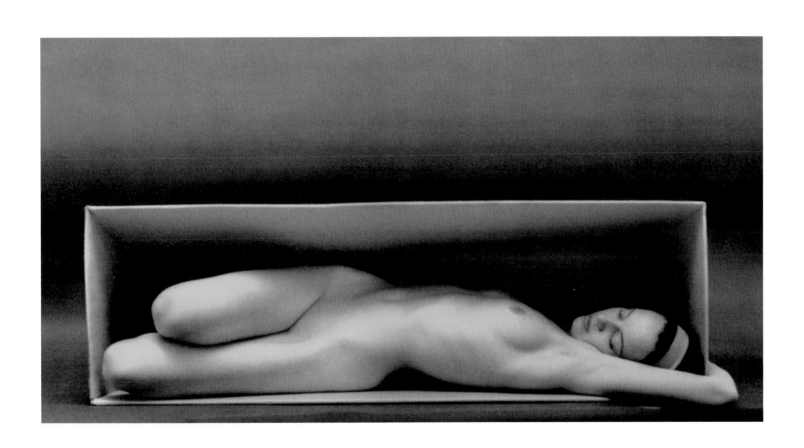

PLATE 20

IN THE BOX, VERTICAL

1962

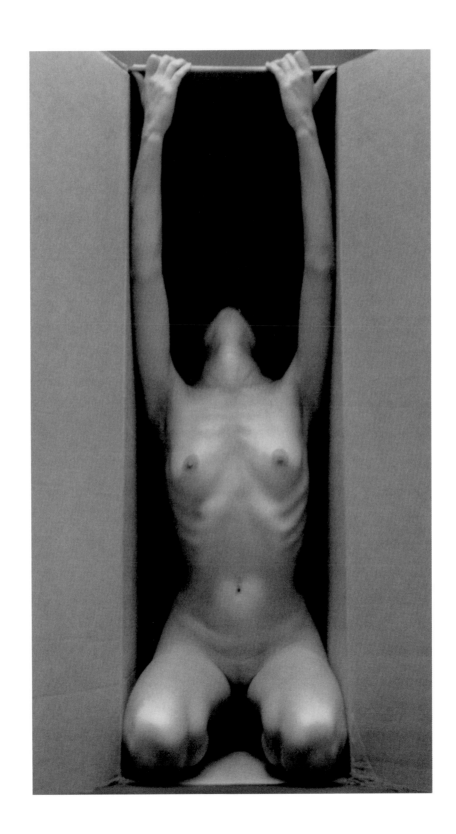

PLATE 21

FOLDING

1962

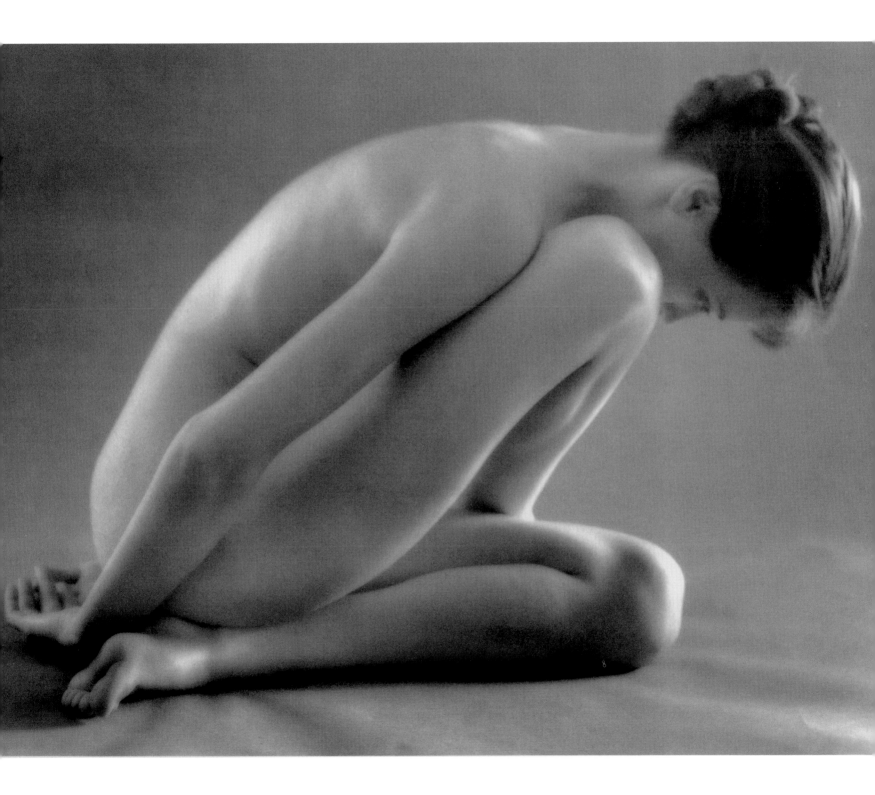

PLATE 22

LUMINOUS BODY

1962

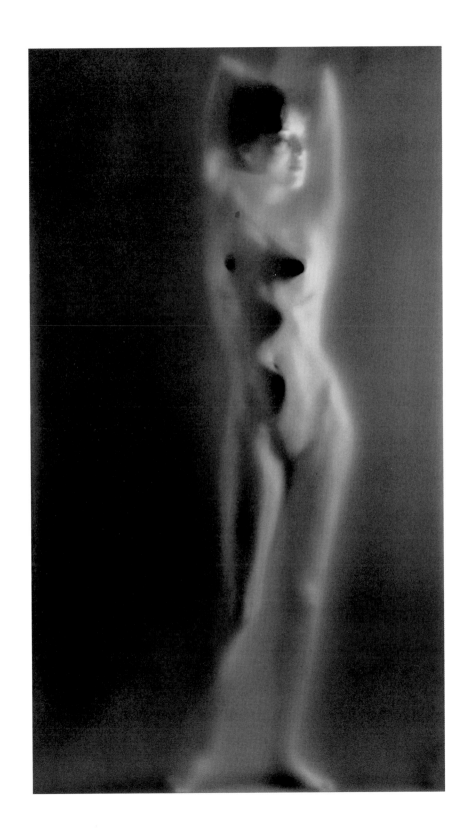

PLATE 23

AURA OF LIGHT

1962

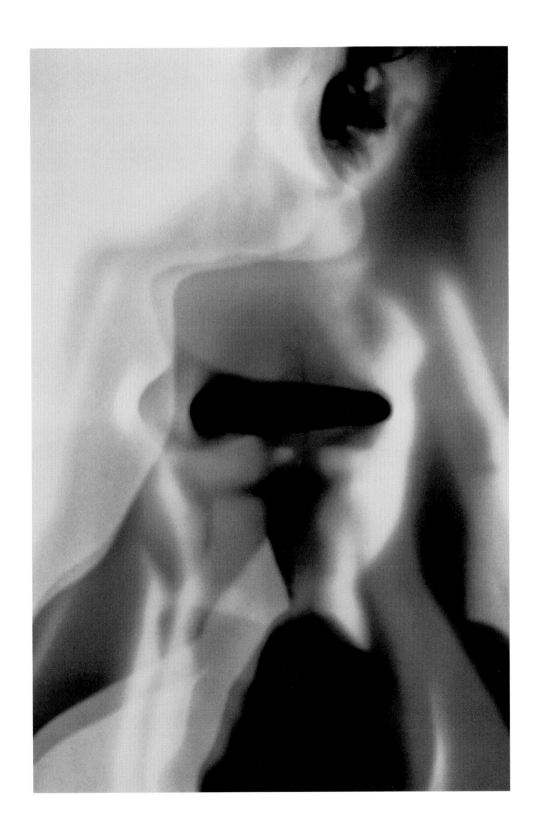

PLATE 24

CONFIGURATION

1962

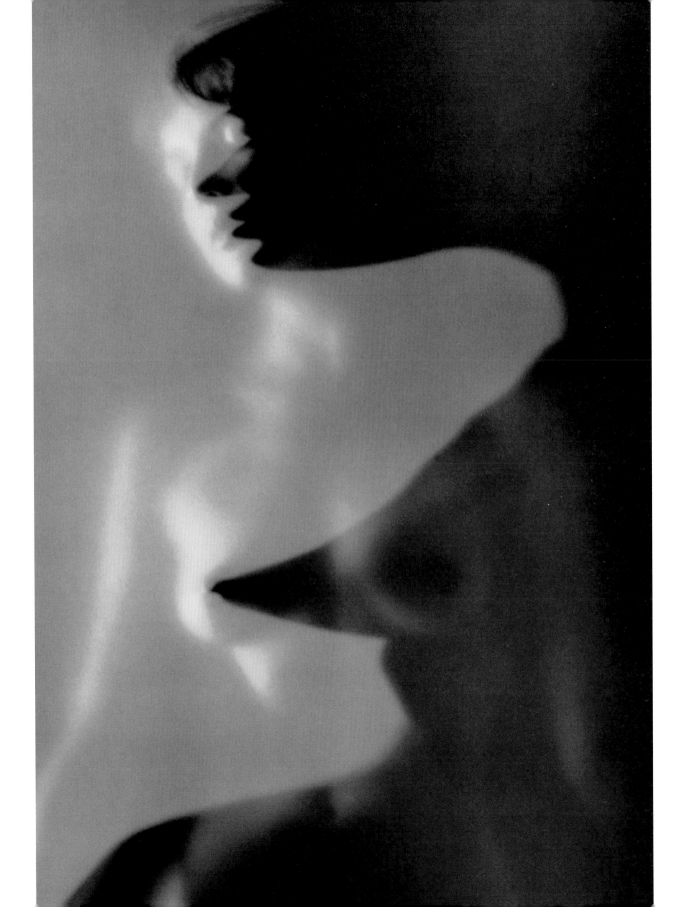

PLATE 25

TWO FORMS

1963

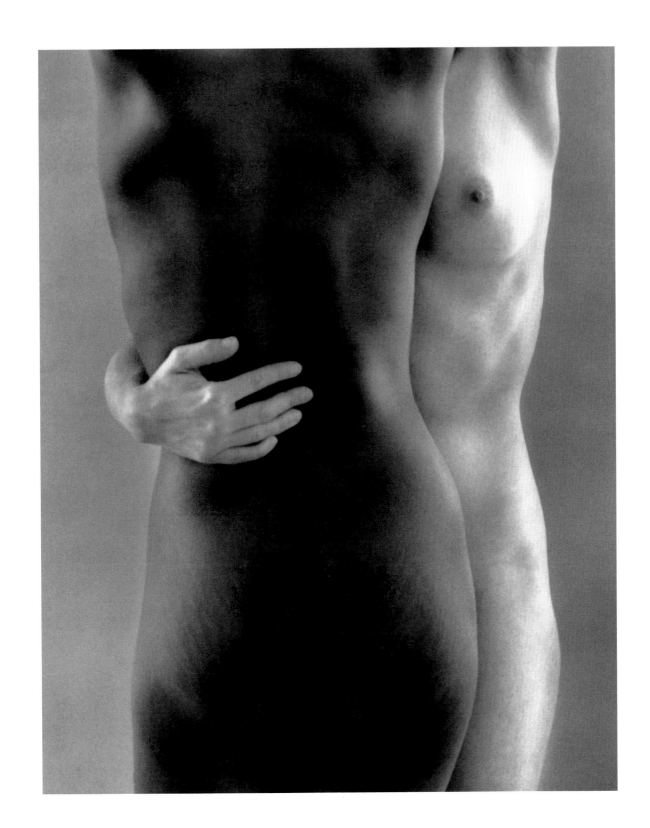

PLATE 26

PERSPECTIVE II

1967

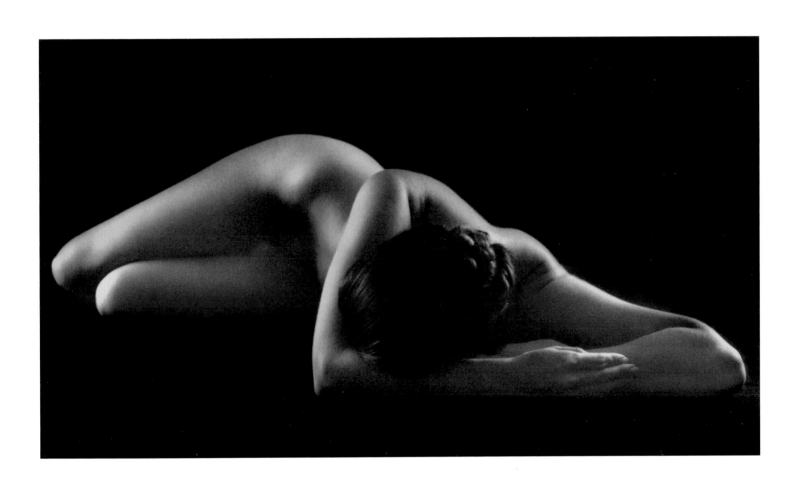

PLATE 27

SAND DUNE

1967

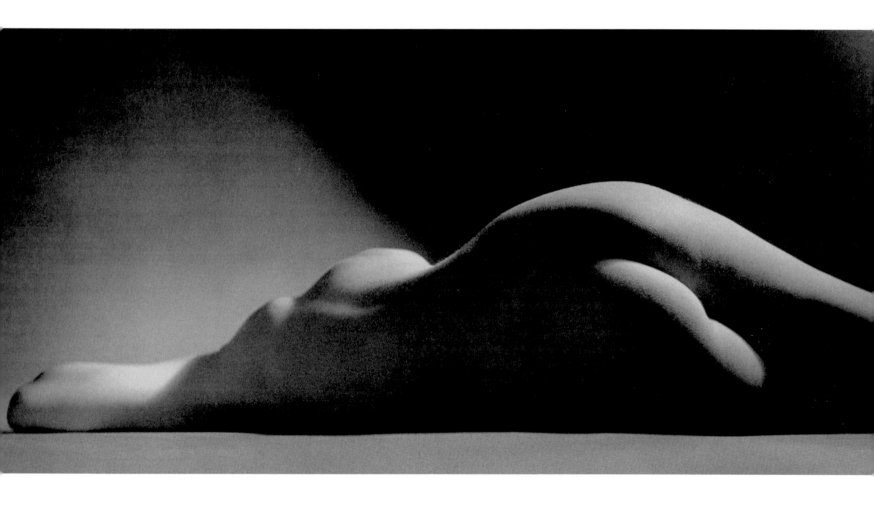

PLATE 28

PROFILE

1967

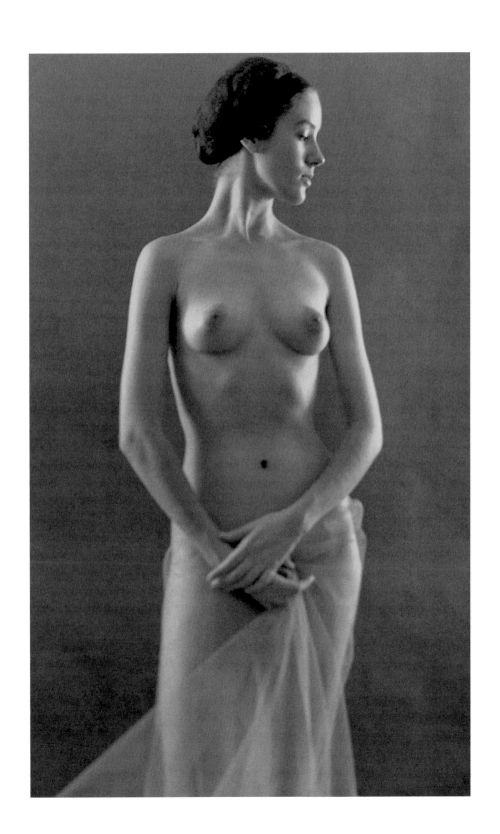

PLATE 29

TRANSPARENT

1968

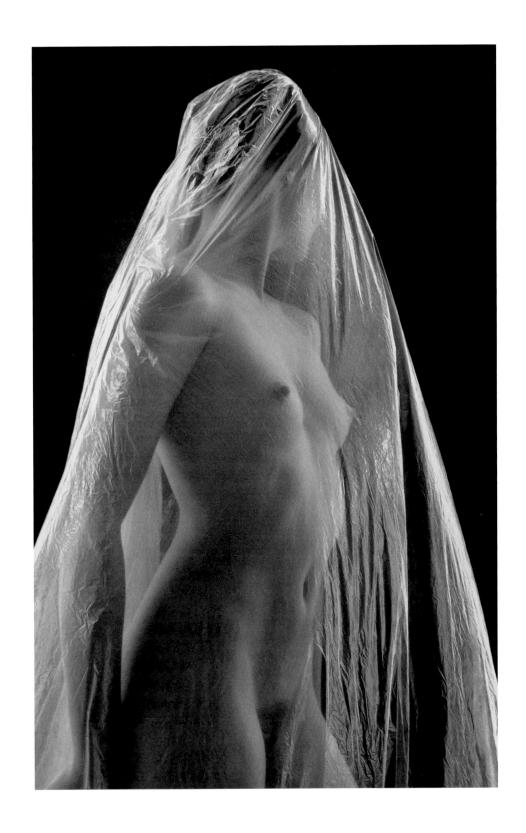

PLATE 30

SILK

1968

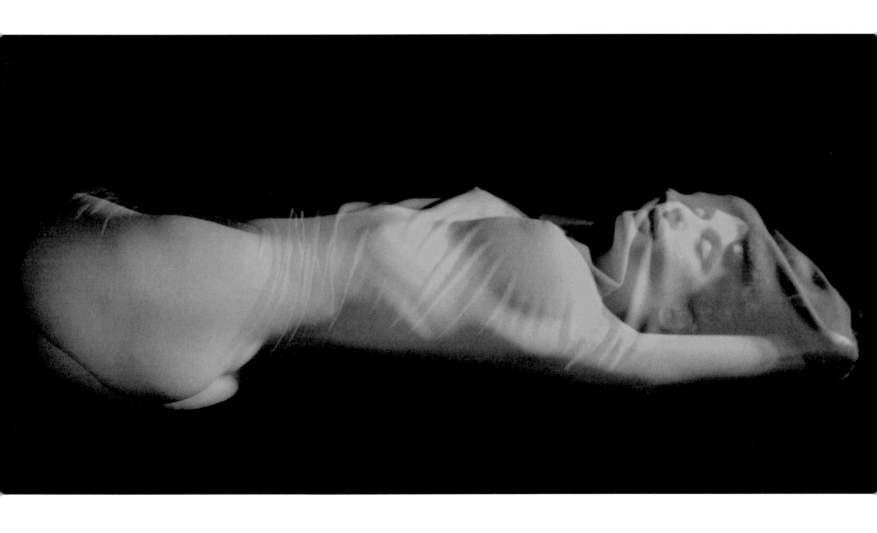

PLATE 31

VEILED NUDE

1968

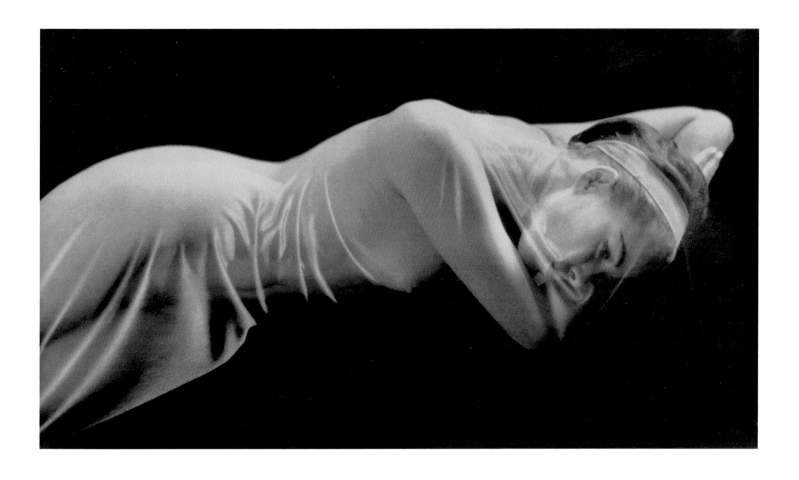

PLATE 32

DREAM FIGURE

1968

PLATE 33

CROSSOVER

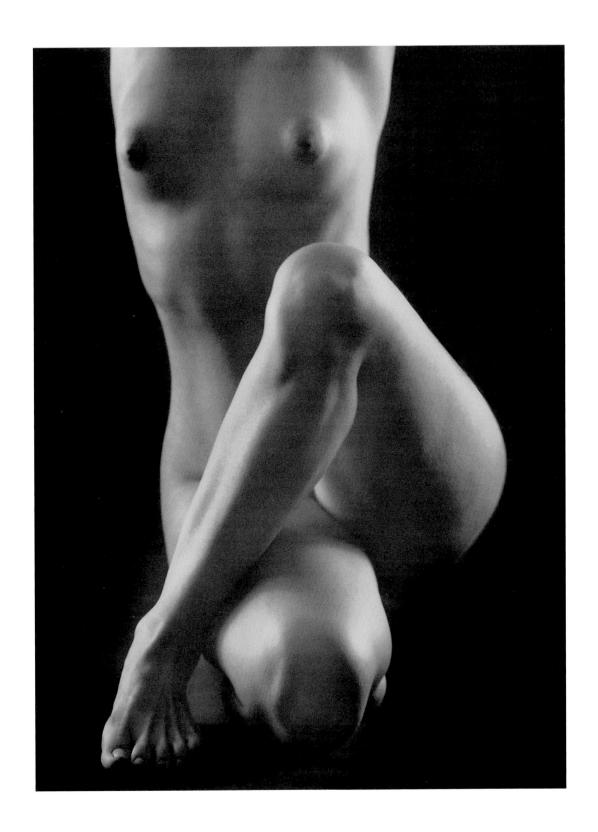

PLATE 34

ANGLES

1969

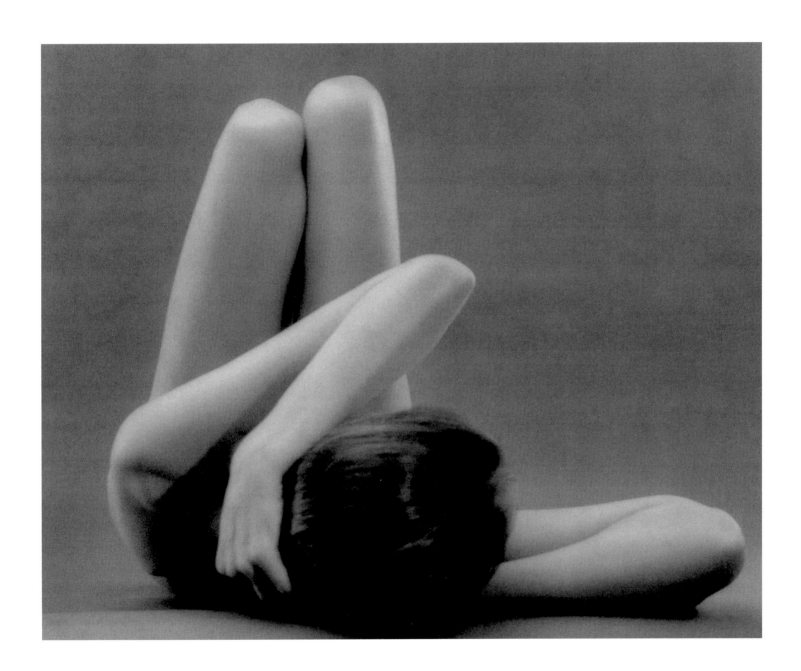

PLATE 35

AT REST

1969

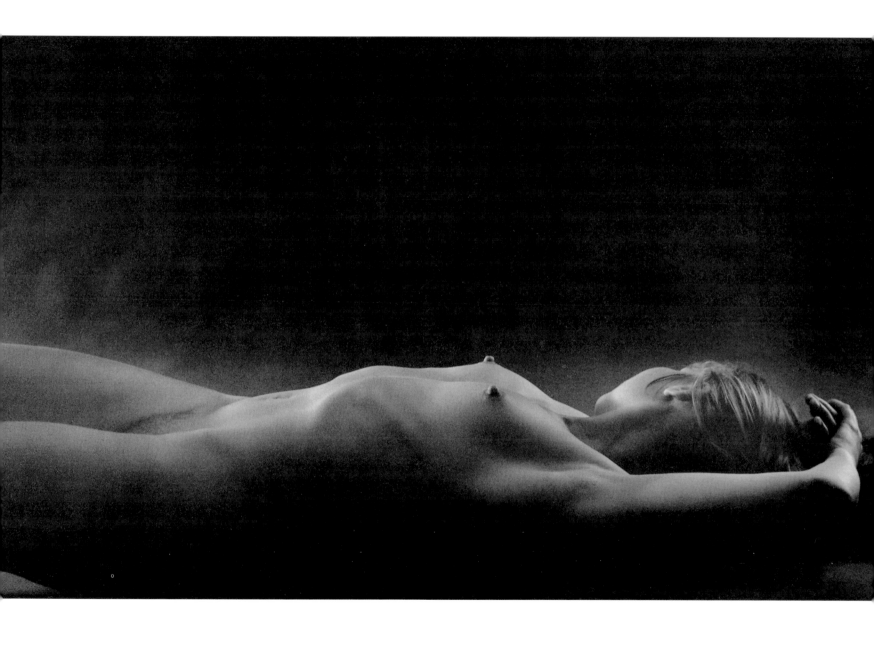

PLATE 36

RICE PAPER

1969

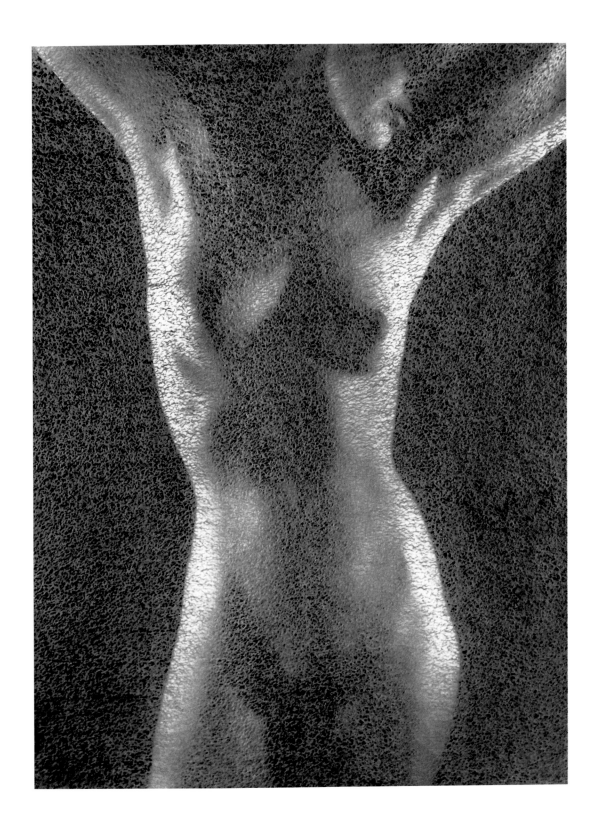

PLATE 37

WITHIN

1969

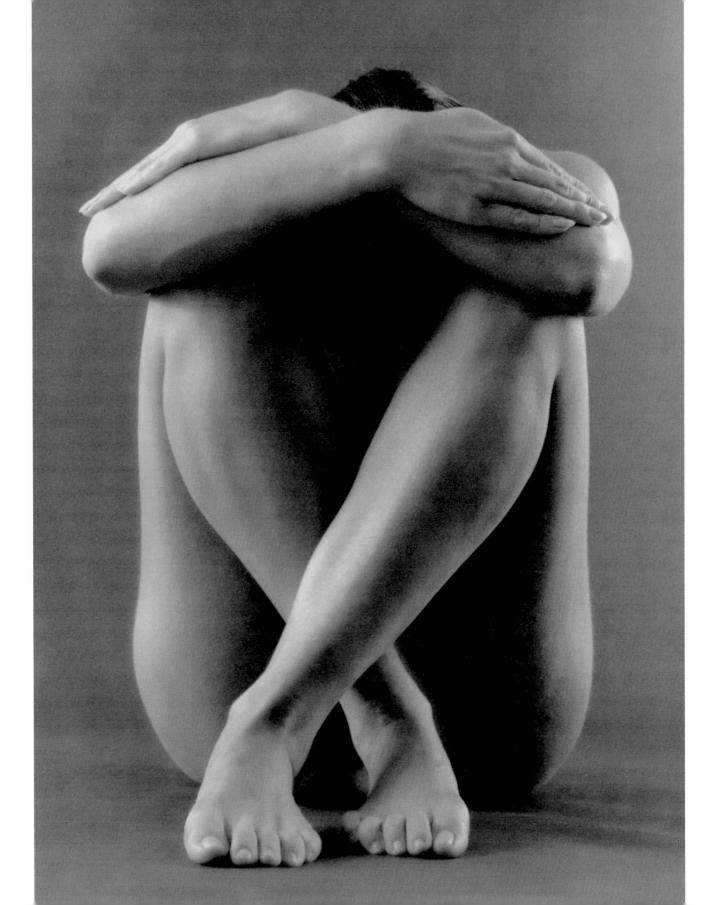

PLATE 38

DARK TORSO WITH HANDS

1971

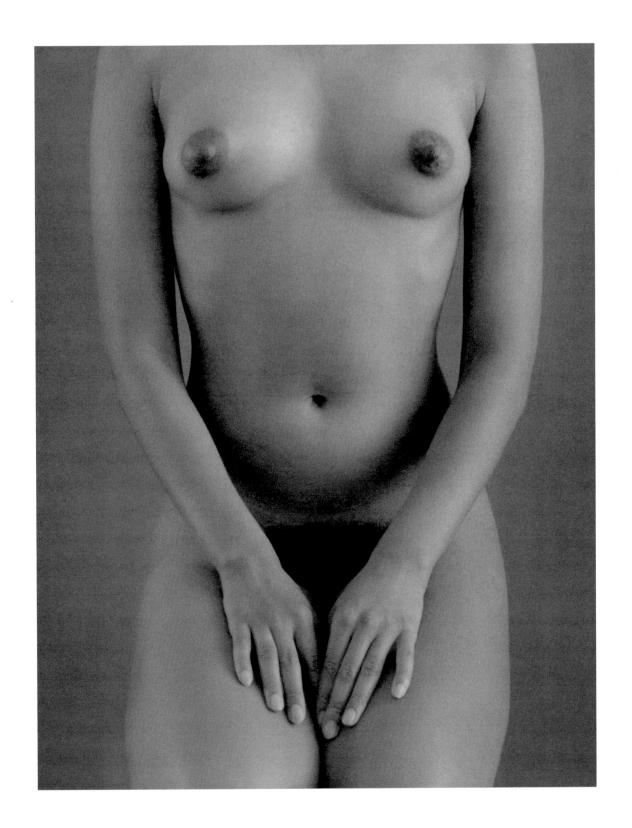

PLATE 39

HOURGLASS

1971

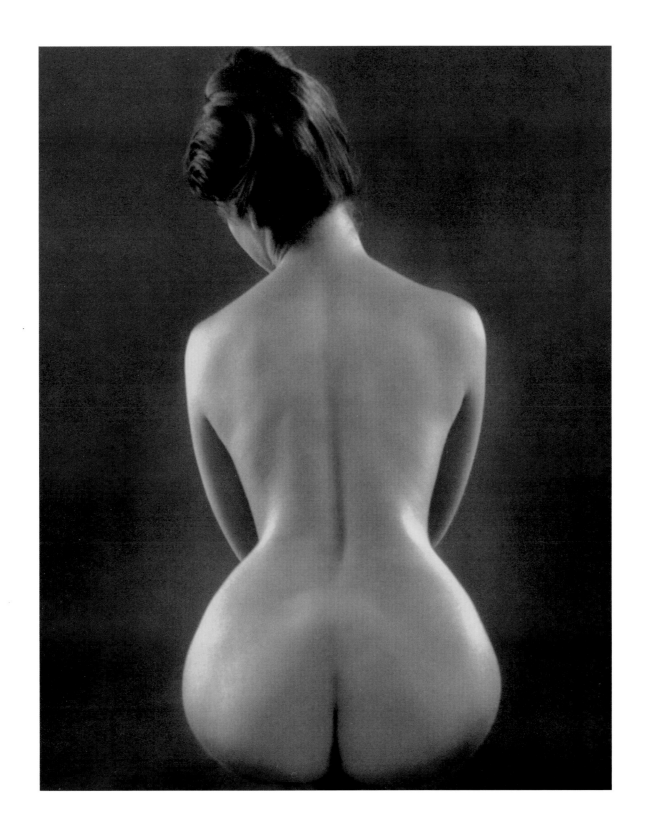

PLATE 40

BALANCING

1971

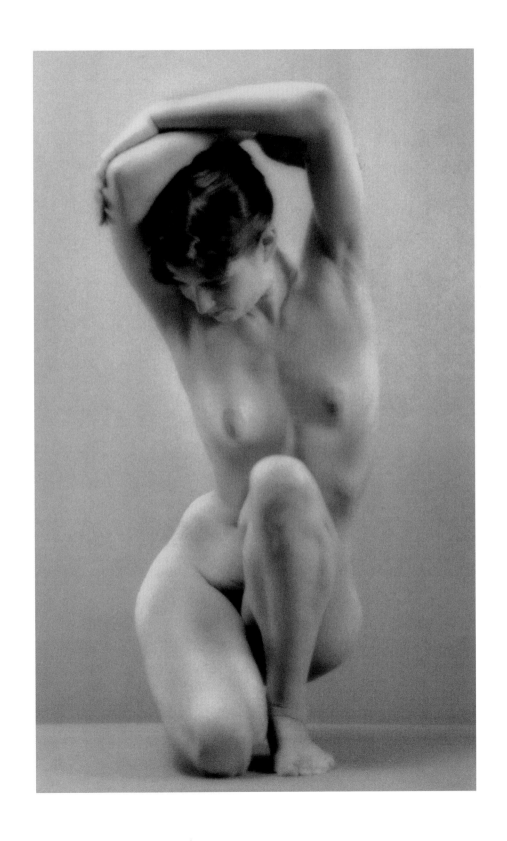

PLATE 41

SPANISH DANCER

1971

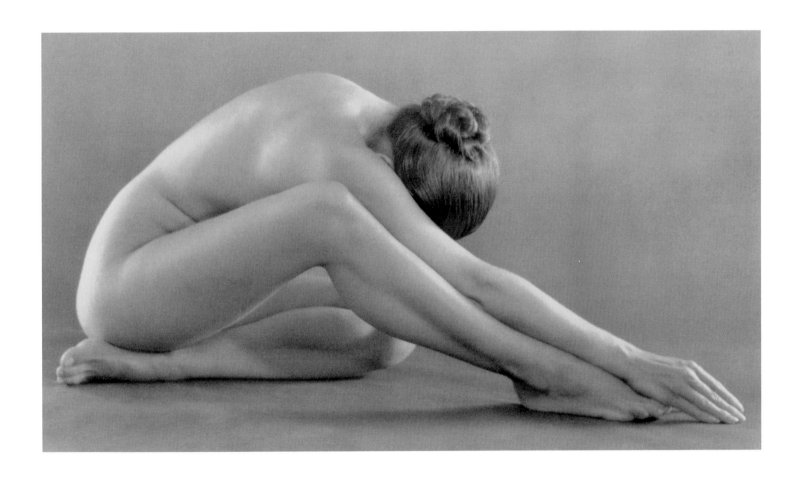

PLATE 42

SYMBIOSIS

1971

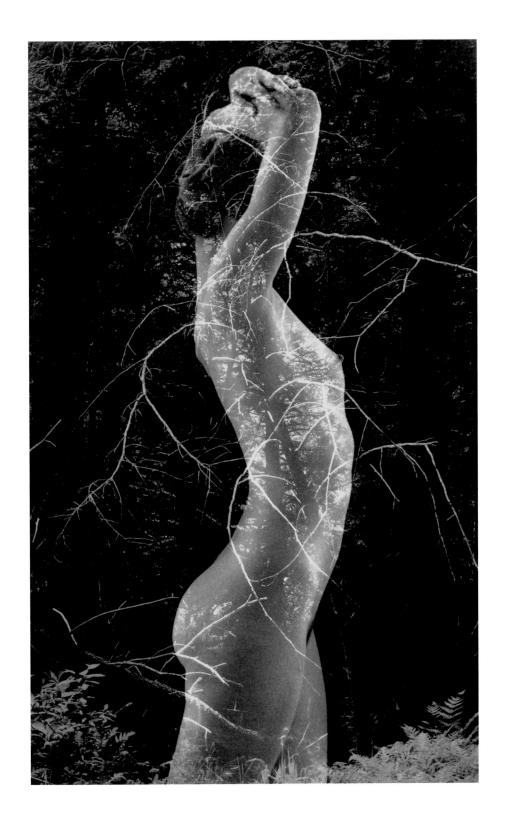

PLATE 43

CURVILINEAL

1971

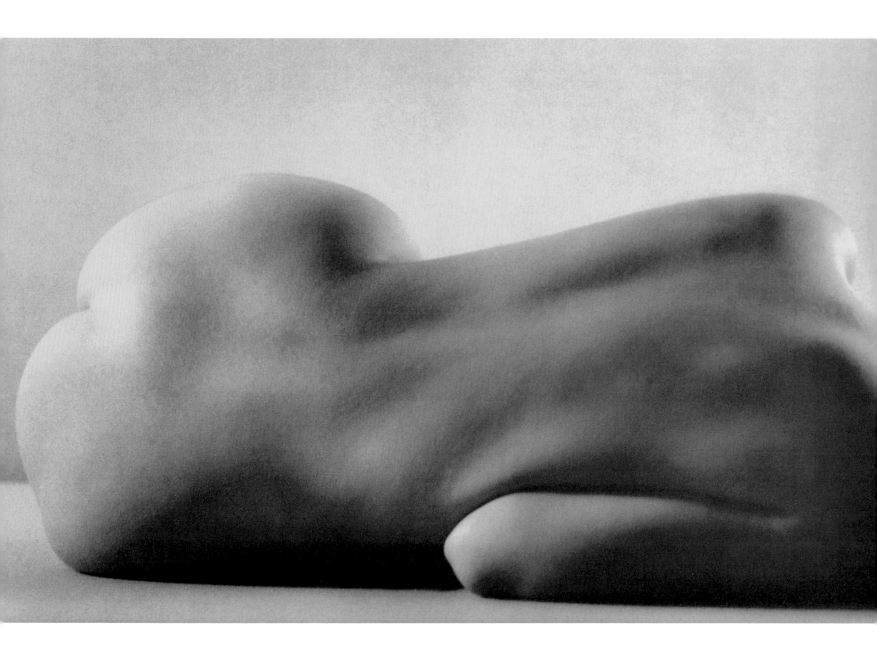

PLATE 44

IN THE WINDOW

1971

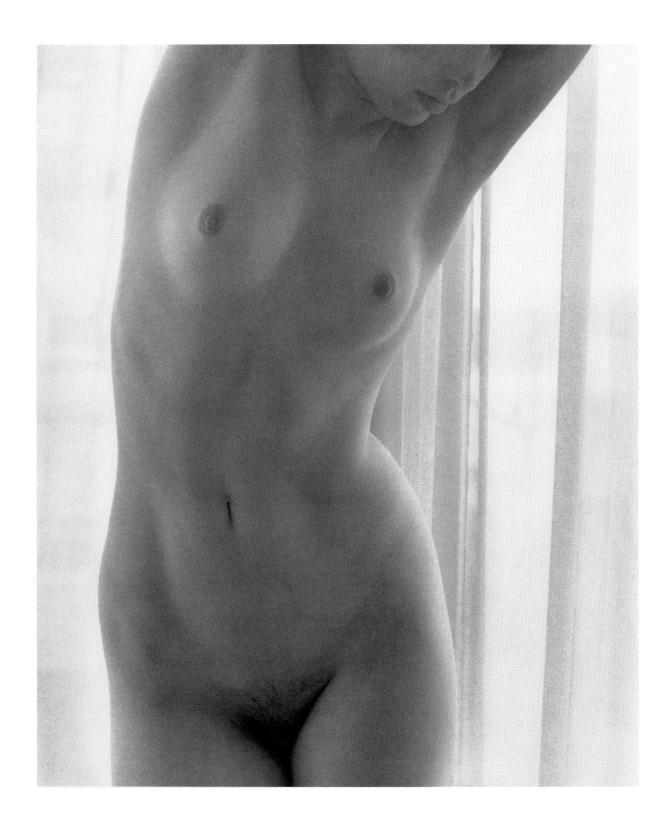

PLATE 45

SEATED FIGURE

1972

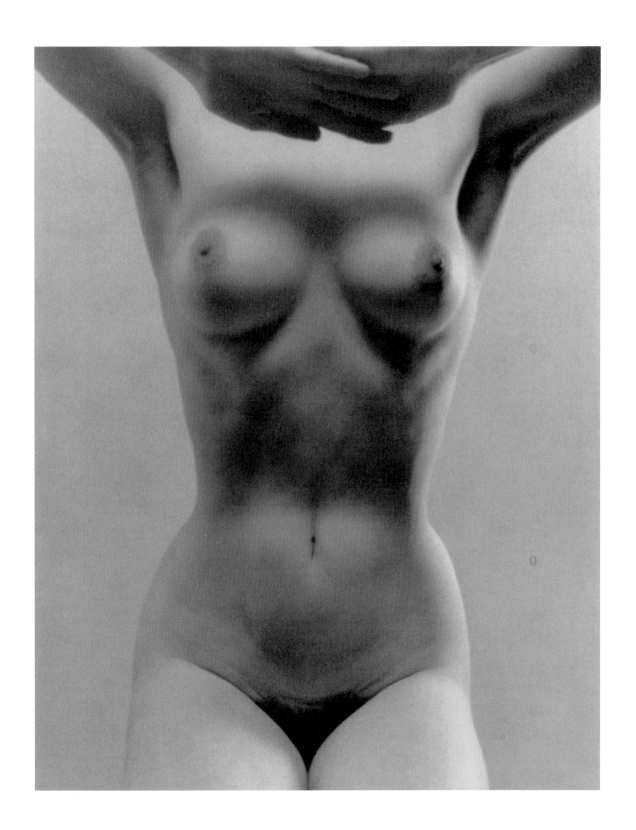

PLATE 46

RESTING

1972

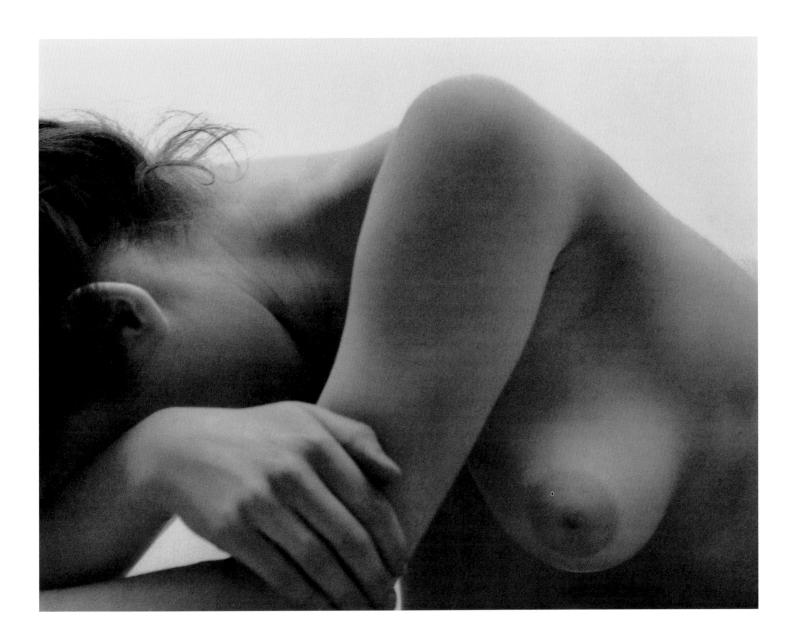

PLATE 47

DOUBLE VISION

1973

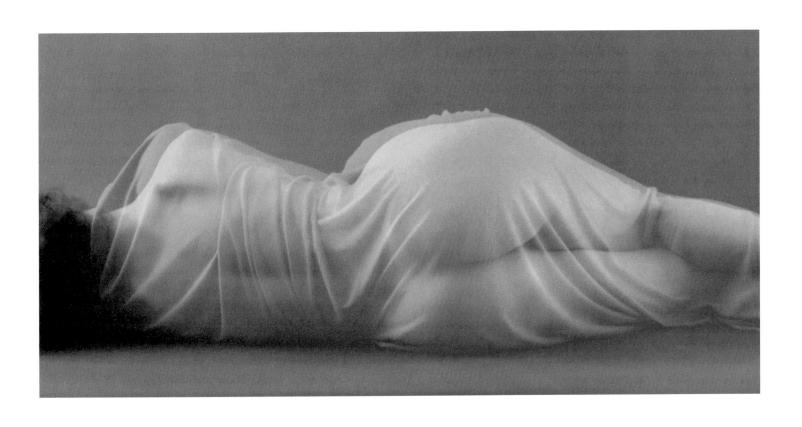

PLATE 48

VEILED BLACK

1974

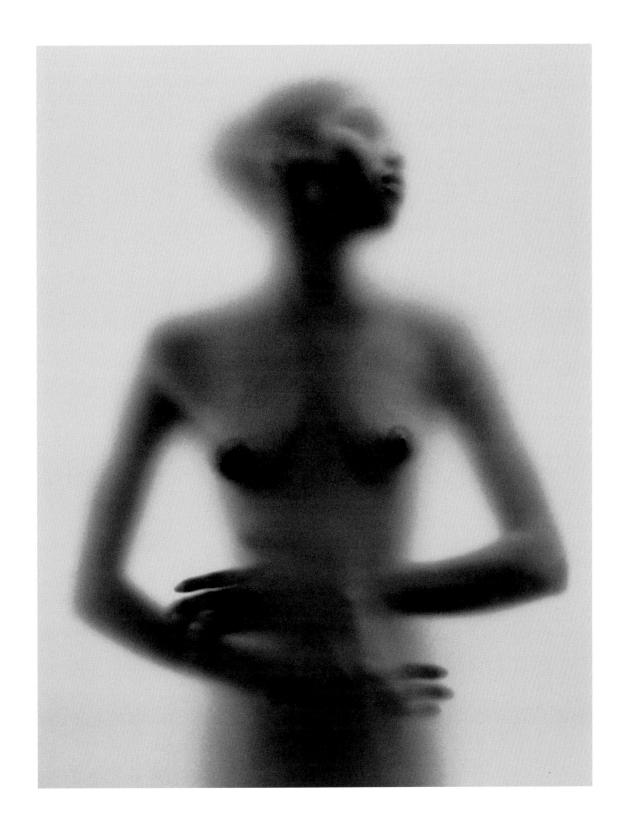

PLATE 49

HIPS HORIZONTAL

1975

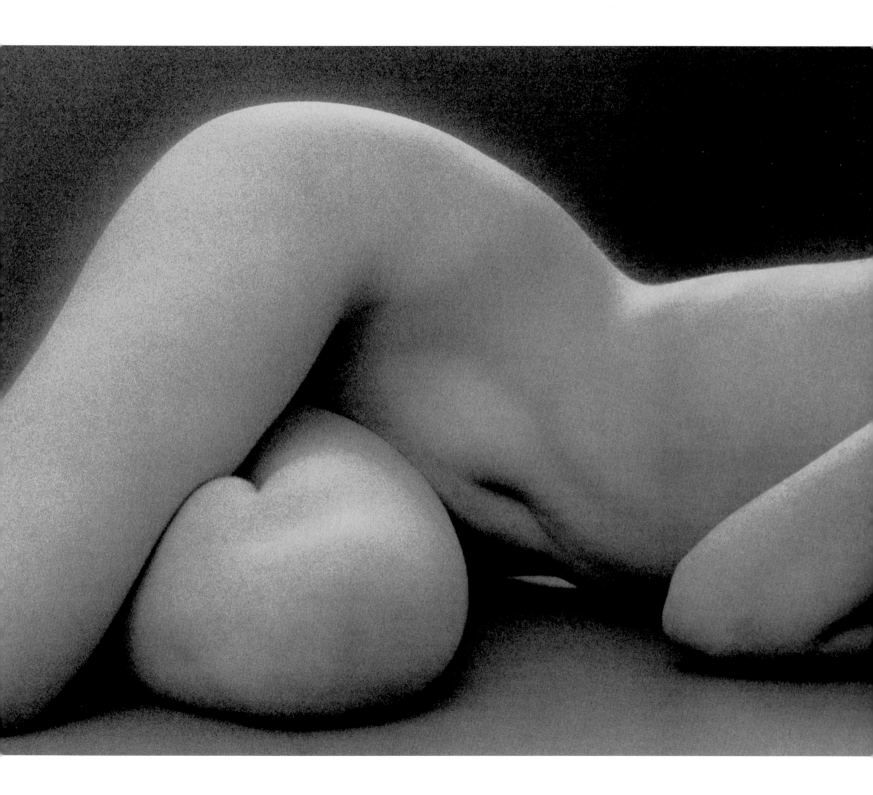

PLATE 50

KNEES AND ARM

1976

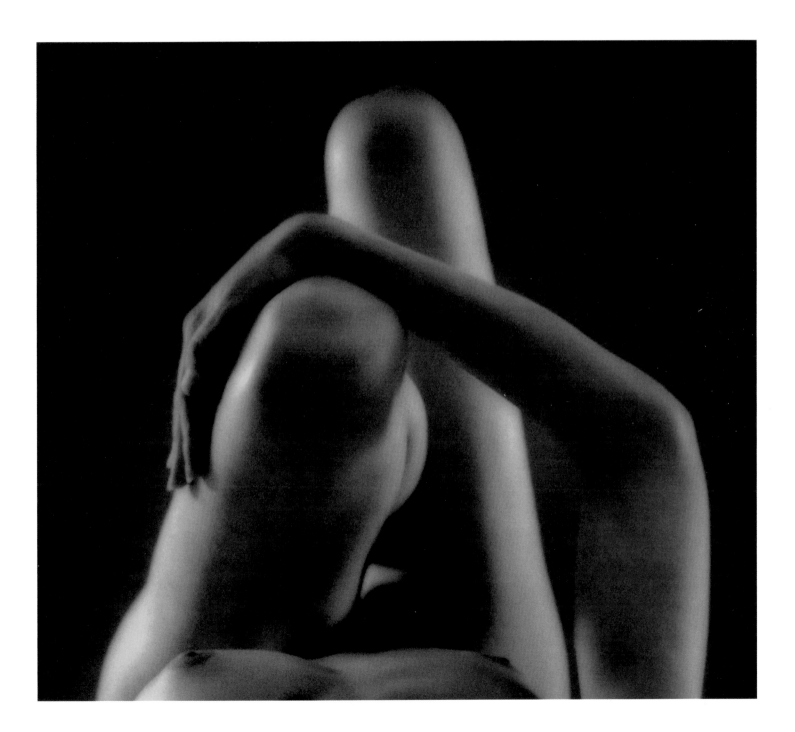

THE NUDE

symbol and light

DURING FIFTY YEARS OF PHOTOGRAPHING THE NUDE, Ruth Bernhard created a collection of images that demands historical attention as well as a philosophical perspective. Her contribution to modern photography and to the history of the nude in art was both pioneering and unique. Bernhard was the only one of her generation of photographers who undertook a lifelong mission of photographing the nude with the aim of revitalizing a classical standard of beauty, one based on an appreciation of the female body as part of a unified humanity. Working intuitively beyond cultural stereotypes of women, she reenvisioned the female nude in the abstract language of the black and white print. She began this task not just as a study of form but, as any passionate artist would, by following the driving force of her own inner vision. Bernhard's images are focused meditations on the beauty and strength of the life force itself.

Beauty is an idea. Indeed, beauty itself is a fiction that changes shape from era to era and from culture to culture. One such fiction took hold of the Greek mind of 2,500 years ago, in response to a cultural need among the artists of the time to develop a means for aesthetic detachment. Through the ideal forms given to their gods and goddesses, the ancient Greeks sought to resolve the abiding tension of passions evoked by the physical body against the "purer" demands of reason, art, and religion, so that they might achieve an enlightened celebration of cultural and aesthetic perfection. This ideal has dominated the art of the Western world ever since.

During the past several centuries, however, the legacy of our Western heritage has taught us that mind and body, the masculine and feminine parts of our being, are inherently separate. Such a divisive concept has rendered our sense of self fragmented and vulnerable because the primary reference for self is the body. The more polarized these ideas become, the more apparent it is that, as human beings, we deeply need symbols. We need to believe in an unattainable perfection at the same time that we need to live with confidence in our imperfect earthbound bodies. Bernhard observed that contemporary society remains uncomfortable with the human body:

It is so basic. A human being is an innocent part of nature. Our civilization has distorted this universal quality that allows us to feel at home in our skin. Other animals have coats that they accept, but the human race has yet to come to terms with being nude.

The battle lines between idealism and realism were set under the publicly prudish morality of Victorian society in the middle of the nineteenth century, just as photography—invented in 1839—was beginning to flourish. By this time, the uneasy new middle class formed from the work ethic of the Industrial Revolution showed decided discomfort with the body. In such a society, the heroic stance of the male nude no longer contained meaning for the artist, who turned to nature for revitalization. To resolve this tension, a nostalgic rendering of the nude evolved. The female nude, already a symbol of nature, answered the needs of the time. She became the perfect vehicle for a more subjective artistic expression. Thus, the nineteenth-century European artist portrayed the nude by merging the concept of an innocent primitive in nature with the ideal nude figure intertie from antiquity. The results were often charged with multiple

meanings, as in Edouard Manet's *Déjeuner sur L'Herbe*, wherein the males, rigidly buttoned in their contemporary attire, look upon a woman comfortably relaxed in her total nudity. The woman gazes directly at us with an unashamed and steady stare, as if to challenge any discomfort we experience from witnessing her unclothed body. By placing the nude squarely in reality, Manet shocked the public, for whom a real woman, undressed, could not be considered Art.

The reductionist formulas used by the more academic painters of this period were producing idealized, sexless nudes, forms frozen from generations of imitation. The earliest photographic nudes were created as substitutions for realistic sketches by artists such as the French painter Eugéne Delacroix, who posed the models himself for photographer Jean Durieu. In America, it was also a painter, Thomas Eakins, who first made significant photographic studies of the nude. Other photographic nudes, following the path of realism, were made straightforwardly in the name of science. Most of these were excluded from public exhibitions because they were considered too coarsely realistic, not idealized enough to meet the romanticized standards of the day.

In the 1880s, an aesthetic movement began in photography called pictorialism. This approach gave credibility to the nude photograph as art, because the soft edges of the pictorial image made possible a romanticism of form and created an approximation to painting. An overlay of allegory further served to convince the viewing public of the photographers' "serious" artistic intent.

By the turn of the century, there were a number of female photographers working in the pictorial style, but few who portrayed the nude. One of these was a woman from California, Anne Brigman. Using the natural environment as her studio, she posed herself and her friends as metaphorical spirits of nature. Her photographs gave lyrical expression to the symbolism of the female as the embodiment of the free, untrammeled wilderness. In 1909, Alfred Stieglitz published Brigman's photographs in *Camera Work*, recognizing that the liberating emotional quality of her approach paralleled American women's struggle to achieve the vote.

Less than a decade later, Imogen Cunningham also made pictorially influenced photographs of her naked husband posed in isolated mountain settings of the Pacific Northwest. Exhibition of the images created a scandal. Undaunted, Cunningham returned to the nude time and again during her long life in photography, and her perceptive imagery stimulated her contemporary and friend, Edward Weston, throughout the 1920s. Weston's work on the nude would eventually set a historic precedent for all who followed him in photography.

No study of the nude in photography can deny the importance of Weston's vision, so thoroughly masterful and daring was his personal statement. In his work, even the sole of a foot is expressive. His visual exploration of the female body closely paralleled his passionate search of the landscape for meaningful forms. His work moved from early pictorial romantic nudes, through an extensive exploration of the body, fragment by fragment, until he arrived at a straight presentation of bodies as icons for meditation, rather than as references to personalities.

Although Bernhard was already established as a photographer, it was Weston who awakened her to her life as an artist. The sight of his masterful prints impressed her with the potential for meaning held within the photographic medium. From him, she gained the self-respect necessary to her work with a camera and was inspired to seek wholeness in her life's work.

Acknowledging Weston as her mentor, Bernhard made her own pioneering contribution to the history of photography and to the history of art. While Weston used sunlight in natural settings to illuminate his nudes, Bernhard directed her focus with studio lighting whereby the model is transfigured by light into sculpture. Weston sought to express the nude body as a reality of flesh and texture; Bernhard used her lights to smooth the skin and achieve an ideal radiant form. She experimented with camera and darkroom techniques such as multiple exposures and double printing that extend the limits of Weston's purist approach to the medium.

The hallmark of the Bernhard style is the mastery of the subtleties of lighting. As James Alinder notes in *Collecting Light*, "While Ruth is interested in harmony, beauty and perfection, her overriding concern is with Light itself." As the ancient Greek artist molded his mirror image in sculpture to conform to ideal proportions, so Bernhard, through the medium of photography, expressed her ideals by sculpting form with light.

Indeed, Bernhard's nudes bring vividly to mind the carefully composed harmony sought by the master sculptors of the past. Bernhard profoundly admired Michelangelo, Rodin, and Henry Moore, along with other ancient and modern sculptors. It was her study of sculpture, rather than the work of other photographers, that had the most significant impact on her vision of the nude.

My aim is to make the complicated body appear tight and concise, always remembering Michelangelo's admonition to his students that the test of good sculpture is to be able to roll it down a hill and nothing will break.

Bernhard has often photographed portions of the body in her quest for meaningful form, but the spirit of her approach greatly surpassed the reductive, analytical manner used by many modern artists.

To keep the image timeless, I deliberately minimize the importance of the face, at times eliminating it altogether. This I feel makes the universality of the splendid anatomy more emphatic.

Thus, even in a fragment, or in the rendering of a headless torso such as *Classic Torso with Hands*, 1952 (Frontispiece), Bernhard's nudes convey an energy that expands beyond the frame, forcing the viewer to see past the forms themselves to the larger whole.

These images speak to us of a respect and reverence for the female body, extracting a universal poetry from particular form.

In my life, as in my work, I am motivated by a great yearning for perfection and harmony beyond the realm of human experience. Through the language of symbols and light, I have sought to reach the essence of oneness with the Universe.

Early in her life, Bernhard observed that women were devalued all around her. As a sensitive young woman, she remembered being offended by the way her father, like other men, regarded women.

I admired him, but he made it clear that boys were more important than girls . . . and for him, fathers were the most important.

Rejection of her father's attitude may have been the initial point of departure, but the male-dominated American culture, as she experienced it, brought her a more serious challenge, both as a woman and as an emerging photographer.

I remember the nudes of the 1939–1940 U.S. Annual. There was a girl on a stool flirting with the photographer. She was supposed to be pleasing to everyone. It made me mad! . . . I wanted to express the dignity and simplicity of what it is like to BE a woman without thinking in terms of sexual interest.

In our society, the average attitude of the male toward the female is not respectful. It is irrational. It always comes down to possession. Some photographs of nude women show that men really don't know what they are photographing. They only see the part which interests them, or they distort or dismember the body in ways that are a form of abuse.

I don't feel that one needs to do anything to make the body appear more sensual. Men have photographed the female nude as if she belonged to them. The female body is the bearer of new life; it is so very innocent. That is what I instinctively like about it, and that is why I photograph it.

Her renunciation of a superficial concept of female beauty energized a quest to create nudes that conveyed more than a possessible body or an unapproachable face. Bernhard, in a subtle way, and prior to the current general emancipation of such ideas, challenged the values of our society. Her images, however, are not made to shock; Bernhard was a pioneer, not a radical. She believed that a cultural change in consciousness is possible within the cultural canon.

Throughout her career, Bernhard's photographs were published on an equal footing with those of male colleagues, a fact that pleased her. She was the only woman photographer represented in the retrospective section of *The History of the Nude in Photography*, a 1964 book that was, as the photographer recalled, "a stab at a serious art book, an attempt to go beyond the pinup nudes that inundated picture magazines after the war." She felt compelled to make a substantial statement to accompany her photographs in that volume:

Every artist, in a sense, is a missionary. He tries to convey a message to his fellow man—he communicates the awesome presence of truth and beauty he discovers in the world around him, in its lakes and mountains, trees, rocks, and plants, in its living creatures.

Down through the centuries, poets, sculptors, painters, and now photographers have also been striving to grasp and immortalize the beauty of the human body, both male and female. I see in these forms the elemental relationship to the larger forms of nature, a sense of strength like a rock, and fluidity like water, space like a mountain range.

If I have chosen the female form in particular, it is because beauty has been debased and exploited in our sensual twentieth century. We seem to have a need to turn innocent nature into evil ugliness by the twist of the mind. Women have been the target of much that is sordid and cheap, especially in photography. To raise, to elevate, to endorse with timeless reverence

the image of woman has been my mission—the reason for my work which you see here.

With the exception of Bernhard's, all the photographs in *The History of the Nude in Photography* are female nudes by male photographers, many of whom did precisely the kind of nudes Bernhard disliked. The work of Amy Andriesse and Nell Dorr is mentioned in the text, but only in passing; Imogen Cunningham, Dorothea Lange, and other women who worked with the nude during their careers could have been considered but were not. It is true, however, that Bernhard was the only woman working during the mid-twentieth century whose series of photographs of the nude stood out as a complete artistic statement on the subject.

Among Bernhard's contemporaries addressing the nude were a number of masterful male photographers. Arnold Genthe, Harry Callahan, André Kertész, Lucien Clergue, Bill Brandt, and Edward Weston each made significant contributions to photography of the nude. Genthe's dancing nudes are the benchmark of romantic pictorial photography. Callahan magically transforms the luxuriant body of his wife, Eleanor, into an Earth Goddess with profoundly spiritual qualities. In the work of Lucien Clergue, we join Aphrodite in waves of watery energy. The nudes by André Kertész and Bill Brandt engage us as participants—the first with wild madness, the second with a mysterious surrealism. Master craftsmen all, these photographers convey their individual love for the female form, whether tinged with worship, admiration, fear, or sensual delight. Examined in the context of these photographers, the unself-consciousness and the forthright strength and simplicity of Bernhard's images provide a marked contrast.

By recognizing the model's presence as an eternal sensual symbol of life and all existence, I experience my own identity . . . as a woman I strongly identify with my model.

For Bernhard, as the photographer, she is the subject, and this mutual identity frees the nude to be herself.

It was no accident that *The History of the Nude in Photography* was published as a tribute to the nude in all her grace and glory. Despite the fact that, at the height of the classical Greek period, the artists celebrated and perfected the heroic male nude, and that the nude male figured strongly in the history of art until the 1700s; from the eighteenth century onward the female gradually replaced the male in prominence, until the nude as a subject of art became, almost by definition, female.

An exploration of classical aesthetics is central to a full appreciation of Bernhard's contemporary achievement. Historic inquiry reveals that there are no Greek sculptures of nude women known to us from the sixth century B.C., and that they were still extremely rare at the height of the classic style in the fifth century B.C. Because the Greeks had no doubt that their great god Apollo had the form of a perfectly beautiful man, their ancient artists concentrated on the perfection of the heroic male body. In the classical period of Greek art, this passion for perfect proportion blended sculpture, philosophy, and mathematics to create an ideal concept of the male body that was ethical as much as it was aesthetic.

Bernhard's reference to classical form was an instinctive, perhaps even unconscious, movement toward rekindling the flame of the proud Greek ideal, but as an ideal for the female body. Just as Isadora Duncan

awakened the Western world to the art of dance by revitalizing an ancient legacy, so Bernhard both recaptured and reinvented classical forms in contemporary photography. The female nude thus draws upon a powerful artistic heritage and ascends toward a position of harmonious and self-contained balance.

The female figures that we do have from the classical era are commonly veiled or partially concealed with drapery. The goddess Aphrodite, a pivotal figure in any historical study of the nude, was regarded with great devotion and reverence during classical times.

Respect for the female body is thus expressed by Bernhard's quest for harmonious form and classic proportion, and her work belongs to that continuum of Western art that seeks to express an ideal beauty. There is, however, a deeper level of exploration that will enrich our appreciation of Ruth Bernhard's photographs of the female nude. Fundamental to this discovery is an examination of the primitive female forms generated for power, fertility, and worship by ancient cultures.

The earliest Paleolithic statuettes of the nude female have been found in sites reaching to the far corners of the European continent. These "Venus figures," dating as early as 25,000 B.C. and created during a period of ten thousand years, were carved in stone, bone, and clay to emphasize the pregnant female form. The ancient matriarchal religions that developed and flourished in prehistoric times were centered on this archetype of the feminine principle—the Great Mother Goddess, whose full, rounded elemental forms of abdomen and breasts demonstrate a female fertility described by Erich Neumann as "prehuman and superhuman."

Bernhard made frequent reference to the inherent fertility of her female figures by describing them as "seedpods." This symbol, derived from the world of plants, sprung from her fascination with creation in all its endless forms. Throughout her growth and life as a visual artist, she returned to nature for stimulus and inspiration. She always sought the essence of any subject—a stone, a shell, a leaf, or a human body—by exploring the inner designs of nature, and she intuitively merged animate and inanimate objects. She explains:

As a child I was deeply curious about the continuity of life and evolution. My interest in plant life, the beauty of sea life, and the study of animals are all very much connected with my appreciation of human anatomy . . . It has occurred to me that we, too, function as seedpods, our bodies representing the past, present, and future—the progression of the human race. My photographs reflect this philosophy. The body, of course, is the pod from which springs all life.

To Bernhard, veiled or draped bodies represent "the unopened seedpod in the transition of becoming." She frequently used the veil to both shroud and reveal the figure, exploring the age-old idea of unveiling and possessing, birth and death. In *Silk*, 1968 (Plate 30), the transparent fabric that wraps the body reveals as it conceals; it invites touch. The veil of *Transparent*, 1968 (Plate 29), recalls the traditional veils that signify life's transitions, as well as the universal iconography of the female body as human seedpod.

Early representations of the Great Mother Goddess merged all aspects of feminine energy into a single abstraction, that of the One Universal

Reality. The worship that centered around such prehistoric figures celebrated this unity and emphasized it in the postures and gestures of sacred sculpture. In time, the spiritual power of the Great Mother Goddess that had been common to prehistoric cultures was reduced and pluralized into a multitude of goddesses, each one reflecting an aspect of the original source. Thus, behind every representation of the female nude, from that day forward, there lies the potent symbolism of the primordial Great Mother. Bernhard intuitively drew upon this powerful underlying primal spirit to express a yearning for a sacred unity of all life in nature. So powerful is this original archetypal image of the feminine that we hardly have a female posture in Western art that is not charged with conflicting cultural and social meanings.

Iconographically, within the range of Ruth Bernhard's studies of the nude, familiar archetypal poses shed their self-consciousness and regain their primal positions of power. Her work recaptures a mythical moment when the body itself was sacred and all the world imagined in it; the eternal body, the endless circle of life and death.

This symbolic expression of uniting opposite forces in the human form is an additional key to understanding Ruth Bernhard's philosophy. She utilized design elements in her images to express an ultimate natural tension of opposites within the body, of the male and female counterpoints of our psyche. The devotional art of India expresses this union of opposites by the literal joining of male and female. Similar oppositions inhabit, and are visualized in, the Taoist system of yin and yang, light and dark, male and female. Western art, however, interested more often in the dynamic than the harmonious, has not successfully maintained a form that comfortably unites these interwoven strands of life. In Bernhard's *Two Forms*, 1963 (Plate 25), a pair of female torsos face each other. One is dark skinned, while the other is lighter; the lines of the first body are broken only by the white hand. The result is a harmony of light and dark shapes perfectly balanced by the hand. The Western world is only now finding new meanings in words like *androgyny* that help introduce this balance of seemingly conflicting forces of nature into our cultural traditions.

In one of Bernhard's most powerful and astounding images, *African*, 1959 (Plate 15), a mythical figure, reminiscent of an African tribal sculpture, is formed from the defiant stance of the kneeling woman. The back is wide and muscular; below, the shadow of the torso gives the pubic area a protruding phallic shape; the hands are pressed on the thighs, fingers spread over the knees in a characteristically male gesture. The startling dramatic effect is primitively hermaphroditic.

Other expressions of primal form can also be discovered in the unusual perspective of the ribbed torso of *In the Box, Vertical*, 1962 (Plate 20), and in the self-absorbed fetal position of the sleeping woman of *Early Nude*, 1934 (Plate 3). Similarly, Bernhard's *Classic Torso*, 1952 (Plate 12), seems a direct descendant of the classic representation of Aphrodite crouching, with one knee raised, a frequently seen motif of especially rich iconography.

In our century, the classical Greek idea of human physical beauty has not survived the crude realities of modern civilization. The human body has been debased. The warrior, an age-old symbol of male strength,

has been stripped of honor by the mechanized horror of modern warfare. Simultaneously, the goddess of love, the female symbol, has been distorted by a preoccupation with sexuality divorced from the mystery of wholeness.

Nevertheless, artists in the Western world have always taken the ideal forms of the ancient Greek deities as a conscious reference point in order to communicate the nude as Art. In Bernhard's photograph *At the Mirror,* 1959 (Plate 16), we are drawn to the youthful athleticism of the body. The lean and graceful form of the nude model has a classic swing of the hip—a traditional method used by sculptors to provide a rhythmical balance to the standing figure. This stance, which reappears throughout Gothic and Renaissance art, in paintings as well as sculpture, had its origins in the standing male nudes of ancient Greece.

The development of the Greek style in sculpture included a search for the mathematical center of balance for the body. Likewise, in a Bernhard nude, all parts relate to the whole. She never resorts to distortion or exaggeration in order to achieve her desired effect. Instead, she persuades us, through angle, lighting, and the harmonious arrangement of forms, that the figure is complete without the frame. The image of woman revealed in her photographs becomes literally as beautiful as she can be—self-contained and not self-conscious.

I am looking for muscle tone and structure to create sculpture . . . It is a challenge to transform the complexities of the figure into harmonious, simplified form, revealing the underlying anatomy while still retaining flow and personal gesture.

Bernhard's most profound images of the nude convey a life force, an energy that extends beyond the frame. Whether she depicts a whole figure or a fragment, there is never a sense of amputation; the form moves toward completion in the mind of the viewer. Bernhard's nudes reach out and engage us in a dialogue. They are not there for us. They are not objects; they live.

As in a mirror, the responsive observer will discover not only the artist's reflection in his work, but his own image as well. In this way we share our findings with each other, communicate, and fill a deep human need.

Indeed, the process of photographing the nude, more than any other subject, can open the window of the human psyche. When we look at the nude we see ourselves, we see the youth we had, the age we will become. If this experience is seriously intended, we move beyond an erotic, personal reaction to the naked body to a higher threshold of our nakedness, our vulnerability as bodies facing death. We are vulnerable when naked because our bodies reveal all we need to know of time passing. We look out from

them; in photographing another body, we can project our hopes, our fears, our visions; we can declare or degrade our common humanity.

Animation of the universal spirit is expressed through the human body, our own unique amazing form in the endless continuum of life. Ruth Bernhard's photographs of the nude bear witness to this liberating wholeness by holding before us the reunion of body and spirit in a visual language of symbol and light.

In her photographs of the nude, Bernhard fulfilled her life's mission to express a full, fearless spiritual female power that will stake its claim in reality as women experience their bodies with renewed self-respect. As our vision clears, our psyches strive toward wholeness.

—*Margaretta K. Mitchell, 1986*

TOWARD THE LIGHT

a biography of Ruth Bernhard

RUTH BERNHARD WAS FOND OF SAYING, "The work is the life of the person," and her life as a photographer was, indeed, testimony of the deeply felt ideas radiating from her artistry. For nearly ten decades, she sustained a rare fascination with the world around her, receiving each new day with a childlike spirit of discovery. The legacy of that attitude is expressed in her photographs, which she frequently referred to as "gifts from the unconscious."

Ruth Bernhard was born in Berlin, Germany, on October 14, 1905. Her parents had married very young and were divorced by the time she was two years old. She saw her mother only twice after that and remembered her as "beautiful with an elegant sense of style." Her father, Lucian Bernhard, on the threshold of a successful career as a commercial designer, was left to secure a new home for his young daughter. Among his colleagues he found two sensitive and loving teachers, Helena and Katarina Lotz, who, along with their mother, made a home for Ruth in Hamburg for the next six years.

During her childhood with the Lotz sisters, the only companions she remembered were the numerous household pets for whom she was entirely responsible. "I was caretaker to thirty-six canaries, many guinea pigs, delicate, dancing white mice, and several dogs and cats." The only child in her adopted family, she learned early to entertain herself and to be an independent thinker. By the age of four she was an avid reader. Her guardians also encouraged her to explore the wonders of the natural world. She would return home from vacations on Germany's North Sea moors with collections of nature's tiny masterpieces: insects, frogs, seedpods, salamanders, shells, and grasses, studying them with her teachers and thus beginning a lifetime of ceaseless inquiry. Bernhard considered these early interests to be the touchstone for her art, as well as for her development as a human being.

Throughout these early years, Ruth's father was her ideal, admired and loved at a distance. As a child, Ruth knew her father's work better than she did his face, because all over Germany's walls were his beautifully designed posters. In time, Lucian Bernhard became known as the father of the German poster.

In 1913, when Ruth was eight, her father remarried. Ruth went back to Berlin to live with him and her stepmother, eventually becoming the eldest of five children in the new family. The Bernhards' home was like an art museum, filled with fine paintings, sculpture, and other wonderful treasures. In the library were rows of beautiful books, many of which had been handsomely designed by Lucian Bernhard. He was by now a famous illustrator, type designer, and advertising artist. He was also a perfectionist who demanded much of himself and others, particularly his children. Many years later, when Ruth brought him her first portfolio of twelve photographs, he responded:

"I don't like this one."

"But what of the other eleven?"

"They are perfect. You are my daughter, aren't you?"

At the age of twelve, Ruth was enrolled in a boarding school in Jena, a town in the former East Germany. The young Bernhard excelled in her academic studies, but she was so talented at singing and acting that her family

predicted a career onstage for her. When she was seventeen, wishing to be on her own, she enrolled in a liberal arts school in Bremen to continue her studies. A year later, in 1923, she astonished everyone by taking her father's suggestion and enrolling in the Academy of Art in Berlin. For the next two years her studies included calligraphy, art history, and type design.

In 1927, Ruth excitedly accepted Lucian Bernhard's invitation to join him in New York City, where he had been living and working for a number of years. She arrived in the United States at twenty-two, brimming with a keen sense of adventure and no idea where her young life was heading. But of one thing she was certain. Despite her art school training, she already had the clear conviction she would not be a designer competing with her famous father. She rebelliously avoided anything that seemed "artistic" in an effort to separate herself from his professional milieu.

For the next two years, Lucian Bernhard provided Ruth the opportunity to learn English and adjust to life in the New World. Finally, the day of reckoning arrived. One afternoon, deciding she was ready to "get to work," he introduced her to Ralph Steiner, photography editor of a popular woman's magazine called *The Delineator*. Her first job, at $45 a week, placed her in the darkroom as assistant to the assistant. It was there that she learned the rudiments of photography with an 8-by-10 view camera. The work was tedious, and Ruth began coming in later and leaving earlier each day. "They put up with me much longer than they should have," she laughed. Within six months she was fired and given $90 severance pay.

With that money, Ruth purchased a collection of photographic equipment from a friend who was in financial straits. Her new acquisition included an 8-by-10 view camera, a sturdy tripod, an excellent convertible lens, and film-holders, as well as darkroom equipment. The fateful gesture changed the direction of her life.

The year was 1929, and Bernhard—like so many others during the Great Depression—was unemployed. Despite the boredom of her initial encounter with photography, she began doing still lifes with the new large camera. Without commercial assignments, she photographed simply for her own pleasure. Money was scarce, and in her efforts to conserve film, Bernhard evolved her lifelong habit of working hours, or even days, to arrange the objects meticulously before her camera, thus expending only a single negative. Among these early images were *Lifesavers* and *Straws*, photographs of frugal purchases made from Woolworth's.

Her first group of photographs was seen by several well-known designer friends of her father who needed pictures done of their work. To her surprise, they expressed a great deal of interest, and her commercial career was born. Soon she was commissioned by Henry Dreyfus, Russel Wright, Frederic Kiesler, Gustav Jensen, and other industrial designers, architects, potters, and sculptors. Eventually she began doing advertising and fashion photography. During this period, she did not think of her photography as art. To her, it was strictly a mechanical craft. The art was in the objects in front of the camera.

Art or not, her first published photograph was placed by Dr. M. F. Agha in *Advertising Arts* in 1931. Entitled *Lifesavers*, this was a photograph she made from a nickel package of candy arranged in a lively staccato design that expressed the rhythm of New York's Fifth Avenue.

While doing commercial work, Bernhard realized that light was the essential ingredient for the making of a fine photograph. Since she preferred working at night when everything was quiet, she decided to buy a set of studio lights. She soon mastered these and often spent several evenings concentrating on a single assignment, attempting to reach the perfection of the object on which she was focused. Time did not matter. As a maturing artist, the legacy of Ruth's father, which demanded perfection, greatly influenced her own standards. It left her always seeking higher goals for herself in her own work.

Jan von Ruhtenberg, who was staff designer in the art department of the Museum of Modern Art, lived in the apartment next to Bernhard's. One day he admired her work and commissioned her to photograph objects for the museum's catalog, *Machine Art*, published in 1934. Among the objects brought to her studio was a restaurant-size stainless steel bowl. One day, a dancer was visiting and Bernhard invited her to pose. She complied by curling up in the shiny, cold, curved interior of the bowl. Bernhard thus made her first exposures of the nude. One was eventually named *Embryo* (Plate 2) and two others entitled *Early Nude* (Plate 3) and *In the Circle* (Plate 1). Later *Embryo* became the first of Ruth Bernhard's nudes to be published, in the 1937 *U.S. Camera Annual*. It would also become her first print sold to a private art collector.

The year 1935 marked a dramatic turning point in Bernhard's life. While vacationing in Los Angeles, she and her father went walking on the beach at Santa Monica with Ken Weber, a local architect. Weber spotted some old friends in the surf and called for them to come and meet his friends. It was Edward Weston with his son, Brett. Upon learning she was a photographer, the elder Weston promptly invited Bernhard to visit his studio. The meeting had a profound effect on Bernhard. From Weston's images, she realized for the first time that photography could be art. The testimony of the thirty-one-year-old photographer acknowledges the power of the experience:

It was overwhelming. It was lightning in the darkness. Here before me was indisputable evidence of what I had thought impossible—an intensely vital artist whose medium was photography. I realized that it is the person who uses the tools and not the tools themselves that matter. It made me cry . . . I stopped photographing for a year, except for my commercial work, which supported me. But I knew then that photography would be my language.

When she returned to New York, she wrote to Weston—beginning what was to become a lifetime correspondence—and received his treasured reply:

Bernhard—
You have excellent eyes. Mine can't harm you. I am glad they were stimulating. And you were too—to me. One day we will meet again. In New York?
Cariñosamente
Weston

When Bernhard returned to her personal work, she discovered a great change in her approach. "After that fateful experience I began to use my camera in a new way. Guided entirely by intuition, not by words or intellectual concepts, I let the image form itself in my imagination."

In 1936, Bernhard set out for Southern California hoping to study with Weston, arriving only to find that he had moved to Carmel. She decided to stay in Los Angeles, setting up a commercial studio in a wooded neighborhood near the Hollywood Bowl. Across the entire front of her narrow building she mounted a bold black and white sign announcing: "Ruth Bernhard, Photographer."

That same year Bernhard received artistic recognition in the form of her first solo exhibition at the Jake Zeitlin Gallery. A second exhibition soon after at the Pacific Institute of Music and Art, called *Eye Behind the Camera*, drew an enthusiastic response from *Los Angeles Times* critic Arthur Miller, who wrote:

Ruth Bernhard has, of course, much more than an eye behind her camera, else she could not produce such exceptionally expressive photographs . . . a mere bit of fabric is found to be as exciting as saint's drapery by a master, and as beautiful; leaves quiver with subtle changes of light that we had never noticed before . . . Bernhard's exhibition marks the arrival of a first-rate artist who photographs.

Three years later Bernhard was drawn back to New York by professional opportunities and remained there until after World War II. Commissions from Macy's, *Vanity Fair*, W & J Sloane's, and numerous other fashion houses and publications kept her commercial time occupied. In the evenings, she continued to pursue her own personal photographic interests. She also began a more active association with other working photographers, and through them her work was reproduced in a number of publications. During this period she became a regular contributor to *U.S. Camera*, and the June 1939 issue highlighted her photographic career under the headline "American Aces."

After warm California winters, New York seemed very cold indeed. Bernhard was already making plans for a trip to Florida when a small notice in the *New York Times* attracted her attention. It announced the 1941 Annual Seashell Exhibition on Sanibel Island. Her decision was made. "On a map I located Sanibel, gathered up the only twenty photographs of seashells I had made, accepted my father's offer of train fare, and off I went, hoping to show my work at the exhibition." In Florida she met Dr. Jeanne Schwengel, a conchologist at the Philadelphia Academy of Science, who invited Ruth to hang all twenty of her photographs. Ruth's finances were in a most precarious state, since her father had only provided one-way train fare, and it was with grateful delight that she learned on the opening of the exhibition that all her photographs had been sold to a Mrs. Alvah Edison, a resident on nearby Boca Grande Island. They brought $25 apiece, and Ruth felt wealthy indeed.

When Ruth returned to New York in the spring, she devoted herself to photographing the shells she had collected in Florida. Dr. Schwengel also loaned her many rare specimens from her superb private collection. She photographed the shells steadily and with great seriousness for an entire year. The prints attracted the attention of many magazines and annuals, among them *Compton's Encyclopedia*, *The Architectural Form*, and *Natural History Magazine*, which in 1943 devoted an entire issue to Bernhard's shells.

During World War II, Bernhard felt compelled to be part of the war effort. A call went out for women to help with domestic food production, and in 1943 Ruth responded to the need for women farmers to replace the men who had been drafted. To prepare herself, she took a two-month course in animal husbandry at the State Institute of Agriculture on Long Island, at Farmingdale, and emerged with her certificate of achievement in the Women's Land Army. For the following two years, during harvest seasons, she was assigned to a large farm in Mendham, New Jersey. There the energetic photographer found herself milking cows, driving tractors, caring for chickens, and performing most of the duties required of an ordinary farmhand. Though the hours were long and the work hard, Bernhard considered this one of the most fulfilling experiences of her life.

In the autumn of 1945, Bernhard returned to New York to reestablish her photographic career. At the urging of a friend, she was persuaded to show her portfolio to Alfred Stieglitz at An American Place. Stieglitz, a champion of photography as fine art, was known to be an outspoken and uncompromising critic. Bernhard brought her prints to him with great trepidation, but to her happy surprise Stieglitz not only liked what he saw, but offered to recommend her for a Guggenheim Fellowship. He also introduced her to his wife, the painter Georgia O'Keeffe, and remarked, referring to Bernhard's photographs of bones and skulls, "You two have a lot in common."

In 1947 Bernhard attended the Edward Weston retrospective exhibition at the Museum of Modern Art in New York. Their friendship had been kept alive through letters, but this was their first meeting in seven years. Bernhard had already decided to return to Southern California to live, and once reestablished in Hollywood, she visited Weston in Carmel as much as possible.

By this time, Edward Weston had been acclaimed as one of the greatest American photographers of his generation, but afflicted by Parkinson's disease, he was near the end of his working life. He lived for ten more years, and it is from her visits during this period that Bernhard claimed some of her most memorable experiences:

To be with Edward was a wonderful experience. Time became timeless. The most intense experience possible is that moment when time no longer exists. It is no longer fleeting; it is standing still for you to fulfill each moment, to give yourself fully to work or play. Few in our present civilization can ever achieve this. Others know it only in isolated circumstances. In my own life, I have experienced this ultimate only when engrossed in work and sometimes in the presence of a few, rare friends. One of these was Edward.

I am still learning from my memory of him—not to be acquisitive, for with one's vision one can possess all beauty; not to be distracted by trifles; to have faith in one's own gifts and to use them with respect and love.

There is no doubt of the debt that Bernhard felt toward Edward Weston. Her honesty in acknowledging his influence honors both those who give and those who receive in student-teacher relationships. If there is an aura of Weston in Bernhard's work, it is in this capacity that the older artist awakened in his protégé.

The Hollywood to which Bernhard returned in 1947 had changed greatly. Though she stayed several years, during which time she became gravely ill and underwent—and slowly recovered from—two major operations, she finally became disenchanted with the vast urban landscape that Los Angeles had become. She decided to move north.

In 1953, Bernhard arrived in San Francisco with her lively trio of dachshunds. Very quickly she became part of the social and cultural fabric of the city. "For me," she said, "San Francisco is an ideal city, intellectually stimulating and naturally beautiful. The ocean and forests are close enough to refresh the spirit; the architecture is always exciting." She participated in the San Francisco Arts Festival for years and celebrated the much-loved cable cars of San Francisco with her photographs for a book by Melvin van Peebles called *The Big Heart*, published in 1957.

In San Francisco, Bernhard found herself in a wider photographic circle. When Ansel Adams saw Bernhard's photographs reproduced in the same magazines which featured his own, he began inviting her to his many social gatherings. It was there she met and eventually formed friendships with many of her future colleagues, among them Imogen Cunningham, Dorothea Lange, Minor White, Don Worth, and Ernst Haas. She also found congenial friends in Ansel and Virginia Adams and continued to be a frequent visitor to their home after they moved to Carmel.

Bernhard was especially close to Wynn Bullock. In 1976, when she published her first portfolio of ten original prints of the nude entitled *The Eternal Body*, Bullock contributed a letter of dedication which read:

I am very touched by you and your work. Our deep love of the meaning of life and the relationship it has with the existence and unity of all things that surpass our power of understanding, but not our deep desire to understand, forms a bond between us and what we search for in our work. I value that bond.
Affectionately,
Wynn Bullock

In 1961, Bernhard began teaching privately, holding classes in the studio behind her house. Along with workshops called "Photographing the Nude" and "The Art of Feeling," she also offered print evaluation sessions for both amateur and professional photographers. Her commercial assignments continued through the end of the decade, but she gradually wound these down as the demand for her teaching escalated. Eventually Bernhard headed courses for the University of California Extension program, and by 1967 she was holding regular seminars entitled "Seeing and Awareness." Central to her teaching is her own self-described role as "a catalyst . . . whose function it is to arouse in the photographer an intensified awareness of his potential creativity." Her classes focused on the basic issue of observation and visual communication, with exercises conducted to facilitate the development of personal vision and to explore previously untapped areas of authentic feelings within each participant.

In the 1970s Ruth Bernhard became a regular instructor in the Ansel Adams workshops held in Yosemite, and later in Carmel. Later, as one of the most respected and acclaimed instructors in the photographic medium,

her teaching spread to include lectures and master classes throughout the United States, Europe, and Japan.

But I do not consider myself a teacher. I look upon myself as a gardener cultivating the fertile soil, encouraging students to intensified awareness of their potential creativity. The emphasis is on feeling, self-expression, and growth. The exchange between the young photographers and myself I find extremely nourishing. Many of my students have become close personal friends with whom I spend time discussing life, art, and photography. It is replenishing for my spirit.

Although Bernhard had photographed the nude as early as 1934, a major body of her work was created during her intensive period of teaching in the 1950s and 1960s. For her, as for generations of artists before her, the nude was the greatest challenge.

Students wishing to study the art of photographing the nude are always surprised at the difficult task it is . . . The photographer must become critically aware of the difference between seeing with his own eyes and with the non-discriminating vision of the chosen focal length of the camera. Giving classes in photographing the nude was an experiment for me. I had no idea that I would be able to teach something that comes so intuitively to me.

Bernhard's first nudes of her San Francisco period were photographed in her living room facing the street to the south. She first taught there, as well, but soon it was necessary to find a larger area elsewhere to accommodate her following. When the studio behind her house became available, she set about making a separate space for photography. There she built a platform and upholstered it with foam so the model would be comfortable for long poses. She then made a concave shape for a background based on a movie studio she had seen. With two sheets sewn together, fastened taut to the semicircular frame and sprayed "Zone-V gray," she had a small but satisfactory studio. The final touch was the placement of foil on the ceiling to bounce the light as an approximation of daylight.

Through her study of the nude figure, Bernhard became able to teach others how to use light to create sculptural form. In her studio, students participated in her meticulous attention to the act of seeing. She carefully instructed in light and lighting, exploring not only the usual luminescence on the figure, but also the infinite possibilities and subtleties of lighting that cause the figure to bask in its own luminosity. Bernhard was a consummate craftswoman of these techniques. "Learning to experience light cannot be achieved in just a few lessons. I believe it must become part of one's every waking moment." Philosophically, Bernhard experienced light as the power of life itself—the very vehicle of vision.

In 1974, as Bernhard neared seventy, friends encouraged her to assemble collections of her photographs. Two portfolios, *The Eternal Body* and *The Gift of the Commonplace*, were completed in 1976. Each of the stamped linen cases contained ten photographs and was limited to an edition of fifteen. The portfolios sold for $2,500 each and quickly disappeared.

During the decade of the seventies, much public attention became focused on the historical and cultural contributions of women. In 1975, a major exhibition and book focusing on the role of women in photography

was mounted that included the work of Ruth Bernhard. It was called *Women in Photography: A Historical Survey* and was curated by Margery Mann and Anne Noggle for the San Francisco Museum of Modern Art. Four years later, Bernhard was once again featured, this time in Margaretta Mitchell's book and exhibition *Recollections: Ten Women of Photography*. A monograph on Bernhard's work, *Collecting Light*, edited by James Alinder, was published the same year by The Friends of Photography. In 1993, *Ruth Bernhard: The Collection of Ginny Williams* was published by Tallgrass Press.

Active until her late nineties (Ruth died at 101 on December 18, 2006), Ruth was at home in her narrow Victorian flat at the top of a straight, steep stairway, where she greeted her visitors. A wiry woman, with short curly hair and a contagious laugh, she appeared far younger than her age at the time. In a front room flooded in light from the south windows, she met with curators, friends, colleagues, and students. Animated in conversation, Bernhard freely expressed her observations about photography, weaving in anecdotes from her countless personal experiences. The conversations were intense and energetic; her mood was frequently reflective, and sentences often ended with a question mark.

Ruth Bernhard always returned to nature for stimulus and inspiration. A perennial, childlike curiosity about the visible and invisible worlds became the hallmark of her work in photography and formed the unique stamp of her holistic, affirmative philosophy of life.

Every day I am aware of the flow and constant change, perhaps I am at the edge of discovering what more our bodies might be able to teach about the spirit of life. At least I am always exploring and trying to understand our relationship to the whole universe. I am looking for enlightenment, so to speak—that is, if I have enough time.

—Margaretta K. Mitchell

PLATES